SURREALISM

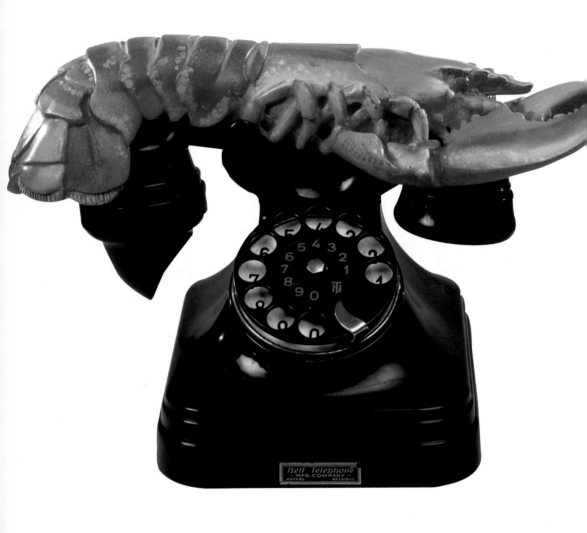

MOVEMENTS IN MODERN ART

SURREALISM

Fiona Bradley

CAMBRIDGE
UNIVERSITY PRESS

PUBLISHED BY THE PRESS SYNDICATE OF THE
UNIVERSITY OF CAMBRIDGE
The Pitt Building, Trumpington Street, Cambridge CB2 1RP,
United Kingdom

CAMBRIDGE UNIVERSITY PRESS
The Edinburgh Building, Cambridge CB2 2RU, United Kingdom
40 West 20th Street, New York, NY 10011-4211, USA
10 Stamford Road, Oakleigh, Melbourne, 3166, Australia

First published by Tate Gallery Publishing Ltd, London 1997

Cover designed by Slatter-Anderson, London
Book designed by Isambard Thomas
Typeset in Monotype Centaur and
Adobe Franklin Gothin

Printed in Hong Kong by South Sea International Press Ltd

Library of Congress Cataloguing-in-Publication Data has been applied for

A catalogue record for this book is available from the British Library

Measurements are given in centimetres, height before width,
followed by inches in brackets

Cover:
René Magritte, *The Annunciation* 1930
(fig.23)

Frontispiece:
Salvador Dalí, *Lobster Telephone* 1936
(fig.30)

ISBN 0 521 62756 7

Contents

INTRODUCTION

The word Surrealism was coined in Paris in 1917 by the writer Guillaume
Apollinaire. He used it to describe two instances of artistic innovation.
The first of these was Jean Cocteau's ballet *Parade*, which had a score
by Eric Satie and a curtain and costumes by Pablo Picasso. In the
programme notes, Apollinaire wrote that the artistic truth resulting from
the evening's combination of elements was a truth beyond realism – 'a kind
of sur-realism'. The second instance was Apollinaire's own play, *Les Mamelles
de Tirésias* (*The Breasts of Tiresias*), which he subtitled 'a Surrealist drama'.
Neither of these artistic events could be described as 'Surrealist' in the
sense in which we now understand it, but in 1924, in the *Manifeste du surréalisme*
which launched the Surrealist movement, the writer André Breton and his
friend Philippe Soupault adopted the word, and 'baptised by the name of
Surrealism the new mode of expression which we had at our disposal and
which we wished to pass on to our friends'.

Breton adopted the word Surrealism to describe the literary and artistic
practice of himself and his 'friends'. As we understand the term today, it
describes a collective adventure centred on the charismatic figure of Breton,
which began in Paris in the 1920s and which eventually encompassed poetry,
painting, prose, sculpture, photography, film-making and interventionist
activity. Although Surrealist artists and writers shared common aims and
explored common themes and subject matter, Surrealism was never a style
as such, and Surrealist art took many different forms. In 1924, the actor and
writer Antonin Artaud, on behalf of the 'bureau of Surrealist research',

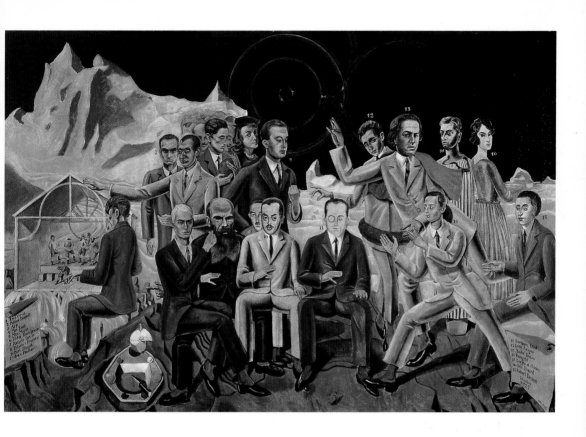

published the aphorism 'Surrealism is not a style. It is the cry of a mind turning back on itself'.

Breton's friends were primarily fellow writers, and Surrealism was initially a literary endeavour. No agenda was set for Surrealist visual artists until Breton wrote *Surrealism and Painting* in 1925, and no specifically Surrealist exhibition space existed until the Galerie surréaliste opened in 1926. *Surrealism and Painting* begins with a section in praise of the visual image: 'The eye exists in its savage state. The Marvels of the earth a hundred feet high, the Marvels of the sea a hundred feet deep, have as their sole witness the wild eye that traces all its colour back to the rainbow ... The need to fix visual images, whether or not these images pre-exist, the act of fixing on them, has exteriorised itself from time immemorial and has led to the formation of a veritable language which does not seem to me any more artificial than spoken language'. However, in the *Manifeste du surréalisme* of 1924 Breton had made only passing reference to painting, using 'Surrealism' to describe, retrospectively, only his own and other writers' activity from around 1919.

Breton met Soupault in 1917 at Apollinaire's apartment at 125 Boulevard St Germain in Paris. He met Louis Aragon, the other 'prime mover' of early Surrealism, at the bookshop 'la maison des amis des livres'. Encounters such as these were of vital significance for Breton, and others are colourfully recounted in his novel *Nadja* of 1928:

The day of the first performance of Apollinaire's *Couleur du temps* [in 1918] at the Conservatoire Renée Maubel, a young man approaches me, stammers a few words, and finally manages to explain that he had mistaken me for one of his friends supposedly killed in the war. Naturally, nothing more was said. A few days later, through a mutual friend, I begin corresponding with Paul Eluard, whom I did not know by sight. On leave, he comes to see me: I am in the presence of the same person as at *Couleur du temps*.

In 1919, Breton, Soupault and Aragon together started the review *Littérature* (*Literature*) which became a focus for the new, young avant-garde in Paris and, as such, a testing ground for the writers whom we now know as Surrealists. Breton was twenty-three, Soupault and Aragon twenty-two – all three 'at that age when life is strongest' (Breton, *Entretiens*, p.51). *Littérature* attracted like-minded writers to Breton and Surrealism: again in *Nadja*, he describes how he came to meet the writer Benjamin Péret in 1920:

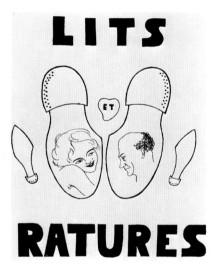

Still in my hotel, Place du Panthéon, one evening, late. Someone knocks. In comes a woman whose approximate age and features I cannot now recall. In mourning, I think. She asks me for a number of the review *Littérature* which has not yet appeared and which someone has made her promise to take to Nantes the next day. She insists, reluctant though I am, upon having it. But her chief reason for coming, it seems, is to 'recommend' the person who has sent her and who will soon be living in Paris. (I still remember the expression 'would like to launch himself in literature' which, subsequently, knowing to whom it referred, seemed so curious, so moving.) But who was I being urged in this more than chimerical way to welcome, to advise? A few days later, Benjamin Péret was there.

2
Francis Picabia
Lits et Ratures
Cover of *Littérature*
no.7, 1 December 1922

Breton's curiosity at Péret's reported enthusiasm for literature is understandable in the light of the deliberate irony and ambiguity of *Littérature*. The title of the review, suggested by the writer Paul Valéry, comes from the last line of Verlaine's *Art poétique*: 'And all the rest is literature'. It was intended to be ironic: 'As far as we were concerned, if we adopted that word as a title, it was through irony and in a spirit of derision in which Verlaine no longer had any part' (Breton, *Entretiens*, p.51). The review became a vehicle for the kind of experimentation which developed, in 1924, into Surrealism proper.

The origins of Surrealism's riches lie in *Littérature*. From 1919, the periodical carried extracts of *Les Champs magnétiques* (*The Magnetic Fields*), written collaboratively by Breton and Soupault. Later, Breton referred to this text as the first Surrealist work: it was written 'automatically', the two authors writing down sentences as they occurred to them at random. 'In order to do this', Breton wrote [*L'Entrée des médiums*] 'all that was necessary was to disregard the context of the external world'. Structure was arbitrarily imposed: 'the only reason for ending each chapter was the coming to an end of the day when its writing had been undertaken'.

Les Champs magnétiques contains a section whose title – *La Glace sans tain* (*The Unsilvered Glass*) – provides an image for the state of mind in which Surrealist work was, from the outset, both produced and experienced. A glass or mirror without silvering becomes a door or a window, a threshold onto a new world. In the case of the Surrealists, this new world was that of the unconscious mind; what they called the 'merveilleux', the marvellous. Surrealism sought communication with the irrational and the illogical, deliberately disorientating and reorientating the conscious by means of the unconscious. This aim is evident throughout *Les Champs magnétiques* and, though achieved in different ways, is common to Surrealism in all its subsequent manifestations. Surrealist writers approached the marvellous initially via stream-of-consciousness or 'automatic' writing. Painters tried automatic methods of production and also looked for other routes. The marvellous was thought to occur naturally, in spaces where the curse of reason had yet to penetrate: in childhood, madness, sleeplessness and drug-induced hallucination; in so-called 'primitive' societies whose members were thought to be closer to their instincts than to the learned sophistication of 'civilisation'; and, crucially, in dreams, the conditions of which the painters attempted to reproduce.

The first visual artists came to Breton somewhat later than the first poets. The German artist Max Ernst's first Paris exhibition was in 1921, and was the result of an invitation from Breton, who wrote a preface for the exhibition catalogue. Ernst already knew of Breton from reading *Littérature* in Germany. In February 1924, Breton bought a painting by André Masson at an exhibition and met him a few months later. Masson was living and working on the rue Blomet and introduced Breton to his neighbour, Joan Miró. The two painters had adjacent studios and talked to each other through a hole in the partition wall. Masson recounts an early conversation with Miró: 'JM: Should one go and see Picabia or Breton? AM: Picabia, he's already the past. Breton, he's the future' (Will-Levaillant, *André Masson, le rebelle du surréalisme*). Miró made, according to Breton, a 'tumultuous entrance' into Surrealism with his first Paris exhibition in June 1925.

Throughout the 1920s, Surrealism was a riot of encounters, inaugurations, publications and exhibitions. As well as the publication of the Manifesto, October 1924 also saw the establishment of the 'bureau des recherches surréalistes', a bureau for Surrealist research which gave members of the group a base other than the café and which was responsible for distributing leaflets and printed Surrealist aphorisms ('tell your children your dreams') around the streets of Paris. In December the same year the group launched *La Révolution surréaliste* (*The Surrealist Revolution*), the periodical which replaced *Littérature* and became the organ of the mature Surrealist movement. Its stress on the visual as well as the literary arts was expressed in its serialisation of Breton's *Surrealism and Painting* and in its illustration of paintings, photography and sculpture – a great rarity in *Littérature*. The arrival of new members of the group was often heralded by publication of their work in *La Révolution surréaliste*: issue 7, in June 1926, included a painting by Yves Tanguy. In 1927 he had an exhibition at the Galérie surréaliste, the catalogue preface written by Breton.

The work of Salvador Dalí and René Magritte appeared for the first time in the last issue of *La Révolution surréaliste*, in December 1929. Magritte had come to Paris in 1927, having previously been active in the Belgian Surrealist group. Dalí had been introduced to the Parisian group by his Spanish compatriot Miró in 1928. Members of the group had visited Dalí at his home in Cadaquès, Catalonia, over the summer of 1929, and judged him an exciting addition to Surrealism at a time when the movement had in fact begun to experience factional differences. The work reproduced in the periodical was *Dismal Sport*. In the same month, a schematic drawing of the painting appeared in *Documents*, a review founded by Georges Bataille, a writer and theorist who gathered around him various members of the Surrealist group (including André Masson) and conducted a bitter ideological battle with the charismatic but ultimately domineering Breton. Bataille had thought Dalí a possible recruit for his alternative group, but, after some deliberation, Dalí did not want to compromise his new relationship with Bretonian Surrealism by allowing his work to be published in *Documents*. He withdrew his permission, and Bataille had to make do with a diagram.

Breton met the challenge represented by Bataille with a call to renewed activity. In 1930 he launched a new periodical to replace *La Révolution surréaliste*, *Le Surréalisme au service de la révolution* (*Surrealism at the Service of the Revolution*), and wrote a second *Manifeste du surréalisme*. The thirties saw the development of the 'Surrealist object', and, in 1933, a third publication, the glossy *Minotaure*. It was also the decade of expansion: in 1936 Surrealism came to Britain with the first International Surrealist Exhibition held at the New Burlington Galleries in London.

In his second Surrealist manifesto, Breton testifies to the difficulties experienced by his movement, the 'ship which a few of us had constructed with our own hands in order to move against the current' from which some members had jumped or been pushed. He insists on his understanding of

Surrealism as a way into a mental world of endless possibility, 'a certain point of the mind at which life and death, the real and the imagined, past and future, the communicable and the incommunicable, high and low, cease to be perceived as contradictions'. The second manifesto repeats the first's obsession with the irrational, the spontaneous and the unconscious: 'the simplest Surrealist act consists of dashing down into the street, pistol in hand, and firing blindly, as fast as you can pull the trigger, into the crowd'.

The second manifesto is a reiteration of Surrealism's aims, and reads less urgently than the first, which drew much of its material from the situation in which Breton and his friends found themselves as young men in the immediate aftermath of the First World War. Breton, Soupault, Aragon, Eluard and Péret had all been conscripted, although Breton and Aragon, being medical students, spent the war working in hospitals. All witnessed the havoc wreaked by the products of Western 'reason', and experienced the wilful destruction which characterised the world's first mechanised war. The internal logic of the war revolted them: Eluard later realised that he must have spent most of his war battling against his future friend, the German Max Ernst, for the same kilometre of no-man's land. In his autobiography, Ernst recorded his impressions of the war: 'Max Ernst died on 1 August 1914. He was resuscitated on 11 November 1918, as a young man aspiring to become a magician and to find the myths of his time.' Using the third person, as though talking about someone else, Ernst documented the war-time suspension or temporary 'death' of his artistic persona.

La Glace sans tain opens with a passage of similarly war-inspired sterility:

> Prisoners of drops of water, we are but everlasting animals. We run about the noiseless towns and the enchanted animals no longer touch us. What's the good of these great fragile fits of enthusiasm, these jaded jumps of joy? We know nothing any more but the dead stars; we gaze at their faces; and we gasp with pleasure. Our mouths are dry as the lost beaches, and our eyes turn aimlessly and without hope. Now all that remain are the cafés where we meet to drink these cool drinks, these diluted spirits, and the tables are stickier than the tables where the shadows of the day before have fallen.

The rest of *Les Champs magnétiques*, and the first manifesto, propose Surrealism as an alternative to this state of hopelessness, as a 'great fragile fit of enthusiasm' to rekindle the stars.

3
Salvador Dalí
Dismal Sport 1929
Oil and collage on canvas
31 × 41 (12¼ × 16)
Private Collection

I

4
Francis Picabia

Portrait of a Young American Girl in a State of Nudity

291 nos.5/6,
July/August 1915

'Like two waves overtaking one another in turn'
SURREALISM AND DADA

At the end of the war, Max Ernst felt reborn as an artist. The movement into which he first channelled his creative energy was Dada, the randomly christened expression of revolt which exploded into simultaneous life in Zürich, Cologne and New York. Dada is often considered the precursor of Surrealism. In fact, Breton's description of the situation is more accurate: the two movements were 'like two waves overtaking one another in turn' (Breton, *Entretiens*). Dada predated Surrealism, and Surrealism survived Dada, but for a while the two movements co-existed in a continuum of shared energy and excitement.

Dada, like Surrealism, ridiculed Western confidence in reason, and denounced the division and categorisation by which the complexities of modern life were neutralised and made safe. Dada artists declared everything to be in a constant and creative state of flux. They were interested more in a mental attitude than an artistic movement: in a bid to determine a radically new concept of creativity, activity was as important to them as anything it might produce.

Dada began in Zürich when the writer Hugo Ball opened the Cabaret Voltaire in the Meierei café in March 1916. Cabaret and music hall were hugely popular in European cities at this period, and Ball thought that the theatre was a form of total expression perfectly suited to the transmission of radical ideas. He wanted to use 'the ideals of culture and of art as a programme for a variety show, that is our kind of *Candide* against the times'. The cabaret became a magnet for artistic revolutionaries: Tristan Tzara, Marcel Janco,

5
Francis Picabia

The Fig-Leaf 1922

Household paint on canvas
200 × 160 (78¾ × 63¼)
Tate Gallery

<small>PORTRAIT
D'UNE JEUNE FILLE AMÉRICAINE
DANS L'ÉTAT DE NUDITÉ</small>

Jean Arp and Richard Huelsenbeck were among the writers and artists who gathered to read their poetry aloud and to discuss the possibilities for a new, non-rational basis for art. After only three weeks, 'everyone was seized by an indefinable intoxication. The little cabaret was about to come apart at the seams and was becoming the playground for crazy emotions' (Hugo Ball, *Die Flucht aus der Zeit*, Munich 1927, translated as *A Flight out of Time: A Dada Diary*, New York 1974). The cabaret staged performances and art exhibitions designed to revolt and disgust an audience, to shock them out of their preconceptions as to the nature of 'art'. In April, members decided to start a periodical called *Dada*: 'Dada is "yes, yes" in Rumanian, "rocking horse" in French. For Germans, it is a sign of foolish *naïveté*, joy in procreation and preoccupation with the baby buggy' (Ball). The periodical was a vehicle through which the 'crazy emotions' of the cabaret could be spread abroad: Dada was born.

Meanwhile, the Dada spirit, if not the name, was flourishing in New York. It was centred on Alfred Stieglitz's *291* publication and gallery, and on the activity of the French artists Marcel Duchamp and Francis Picabia (who both arrived from Paris in 1915) and the American, Man Ray. Stieglitz's *291* was 'dedicated to the most modern art and satire' and the artists, like those in Zürich, sought to overturn all accepted aesthetic and artistic preconceptions and hierarchies. In *291*, and later in his own magazine *391*, Picabia published a series of 'machine drawings', simple adaptations of mechanical diagrams and photographs, subversively captioned by the artist. A spark plug is identified as the 'portrait of a young American woman in a state of nudity', while a light bulb becomes simply *L'Américaine*, the American woman. The tension between word and image in these works is one of simultaneous creation and negation and is recognisably Dada. Picabia stresses the transformative power of art while at the same time ridiculing some of its pretensions. His *Fig-Leaf* of 1922 works in a similar way. The fig leaf of the title initially seems merely to play a traditional role in a vaguely traditional-looking picture: it covers the modesty of the nude figure, a copy after Ingres's celebrated *Oedipus and the Sphinx* in the Louvre. In fact, however, the fig leaf (in French a vine leaf) is central to the whole of the picture's meaning. On close inspection it can be seen that the entire painting,

<small>FRANCIS PICABIA</small>

presented as it is in praise of 'le dessin français' (French drawing, as epitomised by Ingres) is a 'fig leaf' executed over the top of a 'machine painting' similar to Picabia's earlier drawings. Two of his machine paintings had been rejected from the supposedly avant-garde Autumn Salon in Paris in 1922, in which *The Fig-Leaf* was ultimately exhibited.

Duchamp's 'readymades' played even more extreme games with the relationship between art and reality. The readymades were everyday objects – a urinal, a bottle drainer, a stool and bicycle wheel – which Duchamp selected and declared to be works of art. The artist rarely did much to the objects, stating that his selection and his signature of them (often under an assumed name) was enough to guarantee their elevated status as art. The readymades ridiculed the self-importance of art and the art world as Duchamp perceived them, exposing and exploiting a conundrum still current today. Art galleries contain art objects made by artists. Does that mean that anything placed in an art gallery by an artist is art? Duchamp's most famous readymade was the urinal he turned on its back, titled *Fountain* and signed 'R. Mutt'. *Fountain* needed the arrogance of the art world context in order to be read as art, but its readability as art sought to debunk the arrogance on which it thrived.

Between 1915 and 1923, when he declared it 'definitively unfinished', Duchamp made *The Bride Stripped Bare by her Bachelors, Even*, the work known as *The Large Glass*. This is an immensely complicated combination of artistic strategy and chance procedure which results in an impossible machine, a celebration of the end of reason. The glass is divided into two halves, the upper being 'the bride's domain', the lower containing 'the bachelor apparatus'. In 1934, Duchamp published *The Green Box* – notes, drawings and photographs made during the construction of the work. In these notes, Duchamp identifies the *The Large Glass* as a kind of 'love machine', an ironic image of human love-making as a mechanical, ultimately frustrated and frustrating process. The bride is an assembly of mechanical elements who signals to her bachelors, also called 'mallic moulds', with the three flag-like forms contained within her 'blossoming', the visible cloud of her sexual desire. The bachelors respond by pumping 'illuminating gas' along 'capillary tubes' to the suspended 'sieves'. The process ends here, the figurative and narrative potential of the work's formal elements diverted into the anecdotal details of the procedures by which they were determined. The 'gas' in the sieves is actually dust which was allowed to settle on the glass. Duchamp intended it to pass up from the 'sieves' through the 'oculist witnesses', the silvered patterns taken from an optician's eye testing chart ,which allow the viewer, seeing themselves reflected, to enter the closed world of the artist's machine, but this part of the work was never completed. He did, however, show where the gas ended up, near the bride. Its landing position is marked by the 'shots', holes whose position was determined by firing paint-tipped matches at the glass from a

toy cannon. *The Large Glass*, like much Dada work, was intended to provoke and frustrate. Like the performances and exhibitions in the Cabaret Voltaire, it mocks the audience which it nevertheless needs in order to function as an alternative, radical art form.

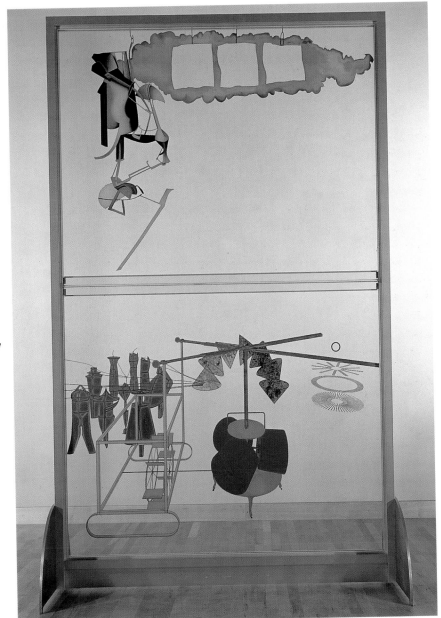

6
Marcel Duchamp

Fountain 1917 / 1964
(third version)

Porcelain
H.35.6 (14)
Indiana University Art
Museum. Partial Gift of
Mrs William Conroy

7
Marcel Duchamp

*The Bride Stripped Bare
by her Bachelors, Even
(The Large Glass)*
1915–23, replica
1965–6

Oil, lead, dust and
varnish on glass
277.5 × 175.9
(109¼ × 69¼)
Tate Gallery

Dada in New York had some contact with Dada in Zürich: Stieglitz was in touch with Tristan Tzara who gradually assumed more and more responsibility for the publication *Dada*. Picabia's *391* was published between January 1917 and October 1924 from wherever Picabia happened to be (Barcelona, New York, Zürich and, eventually, Paris). Epitomising the

internationalist, anti-war and anti-imperialist stance of both the Dada and the Surrealist movements, *391* published the work of Duchamp and Man Ray alongside European-based Dada and, later, Surrealist artists.

Back in Europe, Dada spread by word of mouth and by the movement of artists from Zürich to Berlin, Cologne and Paris. As Tzara took direction of the periodical *Dada*, it began more and more to express, through its typography and graphic design as much as through the material it published, the inspired form of 'organised chaos' which the movement had become. Every contribution – text, advertisement, poem and notice – was set in a different type. The design itself was a call to action: 'each page a resurrection . . . each phrase an automobile horn' (Tzara, *Zürich Chronicle*, December 1918).

Dada had its most political manifestation in Berlin, centred on the activity of Richard Huelsenbeck, Raoul Hausmann, Johannes Baader and George Grosz. Huelsenbeck had participated in the Cabaret Voltaire, performing simultaneous poems with Tzara and Janco. He read the first Dada manifesto in Berlin in 1918, emphasising that Dada is a state of being, that the proper stage for a Dadaist is life, but that the props needed to perform on this stage remain art and poetry. Among the strongest of Berlin Dada's visual images were those of Hausmann, who used collage to attack both the complacency of the news and critical media and the hitherto sanctified integrity of the art image. In his *The Art Critic*, for example, the collaged figure of an art critic is stuck onto a poem-poster of nonsense words. The critic, reassembled from the dismembered fragments of his own methods of discerning and disseminating opinion of artistic 'value' (he is made from parts of newspapers and magazines, stabbed in the back of the neck by a banknote), speaks only gibberish.

In Cologne, the Dada spirit moved through Max Ernst, Alfred Grünewald (known as Johannes Baargeld) and Jean Arp, who came to the city from Zürich. Ernst and Baargeld collaborated on *Der Ventilator* (*The Ventilator*), a radical periodical of which they distributed five issues at factory gates before it was banned by the British Army of Occupation. *Bulletin D* and *Die Schammade* (an invented, composite title) were produced to coincide with Dada exhibitions, the second of which, in April 1920, was one of the most infamous Dada events. Entrance to the exhibition was through a gentlemen's lavatory. The exhibits included a young girl in a communion dress reciting obscene verse, and visitors were challenged to destroy what they did not like.

8
Dadaphone
Cover of *Dada* no.7,
March 1920

9
Raoul Hausmann
The Art Critic 1919–20
Lithograph and photographic collage on paper
31.8 × 25.4 (12½ × 10)
Tate Gallery

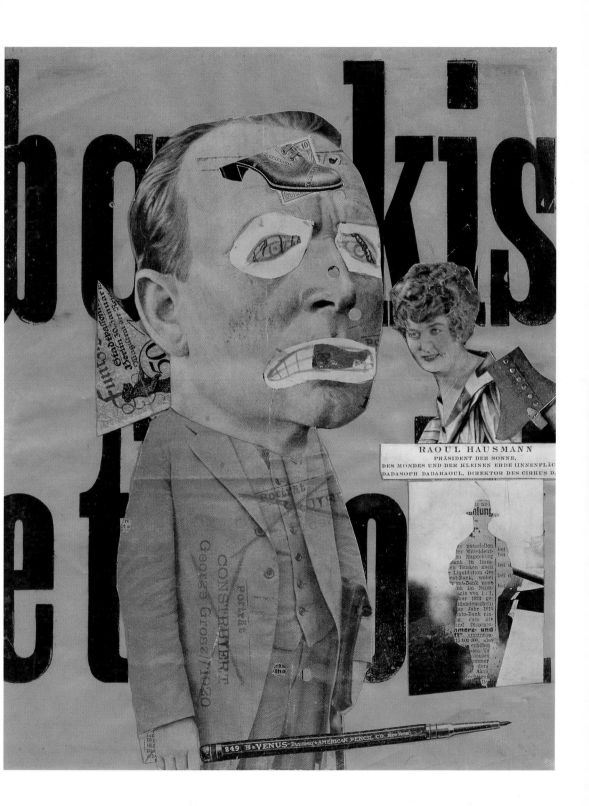

RAOUL HAUSMANN
PRÄSIDENT DER SONNE,
DES MONDES UND DER KLEINEN ERDE (INNENFLÄC
DADASOPH DADARAOUL, DIREKTOR DES CIRKUS DA

Dada art in Cologne was, as elsewhere, concerned with fragmentation, transformation and frustration of expectation. It was also collaborative: Ernst and Arp together made 'FATAGAGAS', described by Ernst as 'FAbrications de TAbleaux GAzométriques GArantis'. These were captioned collages signed by them both. Ernst made the collages, Arp wrote the captions. The first of the series was *Physiomythologisches Diluvialbild* (*Physiomythological Diluvian Picture*). Its fracturing and fragmentation of form, together with the confusion and displacement of its imagery, look forward

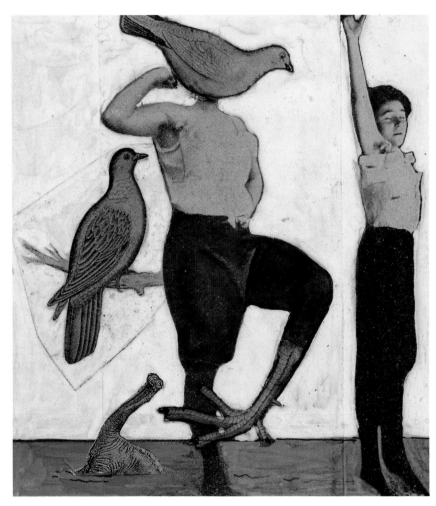

10
Max Ernst and Hans Arp

Physiomythological Diluvian Picture 1920

Collage with fragments of a photograph, gouache, pencil, pen and ink on paper laid on card
11.2 × 10 (4½ × 4)
Sprengel Museum, Hanover

to much of Ernst's later, Surrealist work. One figure is half human, half bird; while the other seems to act involuntarily, in a dream-like, automated state.

In 1921, Ernst had his first Parisian exhibition, and in 1922 he left Cologne to live in the French capital. He and Arp already had contacts there: Cologne Dada was increasingly oriented towards Paris and *Littérature* which, while proto-Surrealist, was also the focus of all recognisably Dada activity in the city. Breton, Soupault and Aragon had started *Littérature* in March 1919, just after the appearance in Paris of *Dada 3*. This contained Tzara's *1918 Dada Manifesto* which, according to Breton, 'lit the touch paper. Tzara's *1918 Dada*

Manifesto was violently explosive. It proclaimed the rupture between art and logic, the necessity of a great negative task to accomplish; it praised spontaneity to the skies' (*Entretiens*). Tzara himself came from Zürich to Paris in January 1920, where, with the help of Picabia (who returned to Paris in November 1919), he organised two series of Dada 'manifestations' or 'Dada seasons'. Breton and his friends at first responded enthusiastically: in May 1920 the thirteenth issue of *Littérature* was dedicated entirely to Dada manifestos written by Breton, Soupault and Aragon as well as by Tzara and Picabia. Several were read out, collaboratively, at a 'manifestation', including this from Aragon:

> No more painters, no more writers, no more musicians, no more sculptors, no more religions, no more royalists, no more republicans, no more imperialists, no more anarchists, no more socialists, no more Bolsheviks, no more politicians, no more proletarians, no more democrats, no more armies, no more police, no more nations, no more of these idiocies, no more, NOTHING, NOTHING, NOTHING.

At the end of the 1921 Dada season, however, the *Littérature* group of writers and artists were growing dissatisfied with the limitations they perceived in Dada's determined negativity: 'The *1918 Dada Manifesto* seemed to open wide the doors, but we discovered that they opened onto a corridor which was leading nowhere' (Breton, *Entretiens*). Breton organised a mock trial of the writer and patriot Maurice Barrès, a symbol of the establishment against which both Dada and the *Littérature* group were striving. A wooden mannequin was tried by Breton in the role of President of the Tribunal. Tzara, giving 'evidence', chose to sabotage what he took to be a ridiculously solemn occasion: 'I have no confidence in justice, even if that justice is done by Dada. You will agree with me, Mr President, that we are all shits, and that therefore little differences, greater shits or lesser shits, have no importance'.

Following this, Breton split with Tzara and with Dada, although he maintained contact with Picabia and, crucially, with the artists Dada had brought him for Surrealism – Arp and Ernst. He launched a new series of *Littérature* and took the group of writers and artists who surrounded him and the periodical into the series of experiments known as the 'saison des sommeils' or 'season of sleeps', a time of intense investigation into the potential of the unconscious out of which, essentially, Surrealism was born. The group explored the possibilities of trance, of dream-like states of mind, in which they could produce imagery directly from their unconscious. The emphasis was on experimentation, on a systematic exploration of creativity which might offer an alternative to the exciting but ultimately destructive anarchism of Dada. In 1922 Ernst painted *At the Rendezvous of the Friends*. It shows the *Littérature* group after their break with Tzara, united in determined yet unexplained activity. It has been suggested that the strange poses in the painting refer to some of the experimentation conducted during the 'season of sleeps'.

2

'Surrealism, n., pure psychic automatism'
SURREALIST AUTOMATIC IMAGERY

The period 1922 to 1924 saw the members of the *Littérature* group in determined quest of the marvellous. They met in cafés and at each other's houses and studios, to write and speak from a state of trance. Aragon chronicled the experiments in his *Une Vague des rêves* (*A Wave of Dreams*) of 1924:

> First of all, each of us regarded himself as the object of a special disturbance, struggled against this disturbance. Soon its nature was revealed. Everything occurred as if the mind, having reached this crest of the unconscious, had lost the power to recognise its position. In it subsisted images that assumed form, became the substance of reality. They expressed themselves according to this relation, as a perceptible force. They thus assumed the characteristics of visual, auditive, tactile hallucinations. We experienced the full strength of these images. We had lost the power to manipulate them. We had become their domain, their subjects. In bed, just before falling asleep, in the street, with eyes wide open with all the machinery of terror, we held out our hand to phantoms . . . We saw, for example, a written image which first presented itself with the characteristic of the fortuitous, the arbitrary, reach our senses, lose its verbal aspect to assume those fixed phenomenological realities which we had always believed impossible to provoke.

The written images which emerged unbidden from these trances were the building blocks of Surrealist 'automatism' or automatic writing. In fact Breton and Soupault felt they had already achieved a form of automatic writing in the spontaneous, collaborative imagery of *Les Champs magnétiques*. In 1924, in the *Manifeste du surréalisme* and in *La Révolution surréaliste,*

11
André Masson

Furious Suns 1925

Pen and ink on paper
42.2 × 31.7 (16½ × 12½)
The Museum of Modern Art, New York

Breton identified automatism as the principal Surrealist artistic practice, the primary route into the marvellous:

> Surrealism, n., Pure psychic automatism, by which one proposes to express — verbally, by means of the written word, or in any other manner — the actual functioning of thought, in the absence of any control exercised by reason, exempt from any aesthetic or moral concern.

Breton's definition stresses the absolute nature of Surrealist automatism: poetry, prose and presumably painting must be generated by stringing together the first words or images which come to mind. For the writers, this meant placing their trust in the creative potential of language itself. In *Le Point cardinal* (*Cardinal Point*), Leiris writes:

> In my mouth, mine of words and kisses, thought and desires become confused, reduced to the unique expression of the utterance.

For visual artists, attempting to find a place within a movement whose development since before 1919 had been entirely in the realm of spoken and written language, automatism meant placing their trust in the creative power of a purely visual language. Their medium was the mark rather than the word, and so they began with automatic drawing. André Masson, in particular, was very successful. He found that he was able to draw, or doodle, in an abstracted state of mind. His pencil called marks from out of his unconscious and onto the paper. Only then did he allow his conscious mind to shape forms out of the marks. His drawings were published in *La Révolution surréaliste*, often alongside automatic poems. Automatic painting, however, proved more difficult. The paraphernalia of painting in oil, the laborious nature of the process, tended to work against the spontaneity of the impulse. Masson's 'automatic' paintings look like translations into oil of his automatic drawings and seem the product of conscious, deliberate hard work. Surrealist painters had to seek another route into the marvellous.

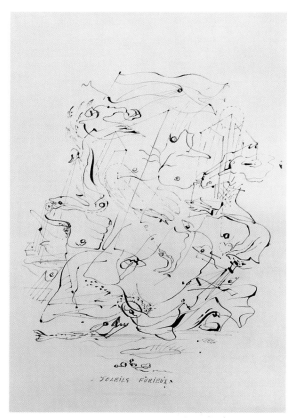

They did this by returning to the first principles of Breton's excitement concerning automatism: that it was a way to catch the unconscious mind unawares and to capture the images of the unbridled imagination. They sought methods of short-circuiting the mind's rational apparatus, making visual images which, like those of automatic writing and drawing, were initiated somehow

12
André Masson

Nudes and Architecture
1924

Oil on canvas
73.7 × 92.1 (29 × 28¼)
Collection Mr and Mrs
Nesuhi Ertegün,
New York

13
André Masson

Battle of Fishes 1926

Sand, gesso, oil, pencil
and charcoal on canvas
36.2 × 73 (14¼ × 28¾)
The Museum of Modern
Art, New York

14 *right*
Max Ernst

Forest and Dove 1927

Oil on canvas
100 × 81.3 (39½ × 32)
Tate Gallery

outside or beyond the artist's will. One way of doing this was to allow chance or collaborative procedures to generate the image. The artist was then not making a conscious choice about how the picture would look, or what it would be about, until it was well under way. A second method was to pursue the analogy between painting and poetry and to force visual language to work more like language as it is spoken or written.

Sand painting was a successful technique discovered and practised by Masson. He would drip or smear glue onto a piece of paper or canvas at random, sprinkle sand over the glue, and then use the resulting sand patches as pre-pictorial inspiration. Like the initial marks in an automatic drawing, the glue and sand gave him a starting point that was unaffected by either his rational mind or his artistic will. Miró has been recorded as working in a similar way, but from an even more arbitrary starting point: he is said to have once made a painting around the traces of a fallen blob of jam.

Max Ernst developed a more or less automatic method of drawing which was translatable into oil paint. He would create a surface pattern by rubbing

with pencil or charcoal on a piece of paper laid over a rough or interesting surface. This technique, similar to that of brass rubbing, he called 'frottage'. It could be adapted for painting by laying a thickly painted canvas over a similar surface while the paint was still wet, and scraping off layers of paint. Paint clung to the indentations of the material underneath so that, again, a pattern was created. This Ernst called 'grattage'. Both frottage and grattage provided Ernst with involuntarily produced marks out of which he could develop finished works. He called the process of calling forth images from out of these textures 'seeing into', and was inspired to do it by the childhood memory of an imitation mahogany panel:

> I see before me a panel crudely painted with large black strokes on a red background imitating the grain of mahogany and producing associations of organic forms – a threatening eye, a long nose, the enormous beak of a bird, with thick black hair and so forth (Ernst, *Beyond Painting*).

The images Ernst obtained by means of frottage and grattage depended on an imaginative transformation of the raw material provided from the initial rubbing. In *Forest and Dove*, for example, Ernst used planks of wood and fish bones to provide a background texture. He then let his imagination play over the patterns the oil paint had found in the wood and bones until they suggested a forest. In the finished painting, the planks have been turned back into trees – the automatic technique which produced the image has suggested to the painter (and now suggests to the viewer) a reversal of the conversion of the natural into the man-made.

Frottage can be related to a much older tradition of painting. The idea of 'seeing' images hidden in non-artistic marks may be traced back to Leonardo da Vinci. In his *Treatise on Painting* Leonardo wrote:

> It is not to be despised in my opinion if, gazing fixedly at a spot on the wall, coals in the grate, clouds, a flowing stream, one remembers some of their aspects; and if you look at them carefully you will discover some quite admirable inventions. Of these the genius of the painter may take full advantage, to compose battles of men and animals, landscapes or monsters, devils and other fantastic things.

Frottage, grattage, sand painting and automatic drawing are all techniques which seek to deny, or at least to defer until a later stage,

the individual creativity of their practitioners. 'In striving more and more to restrain my own active participation in the unfolding of the picture and, finally, by widening in this way the active part of the mind's hallucinatory faculties I came to assist *as a spectator* at the birth of all my works' (Ernst, *Beyond Painting*). Decalcomania was another widely used technique for achieving such detachment. It involved spreading gouache, ink or oil paint onto a smooth, non-absorbent surface such as glass. Paper or canvas was then pressed onto the coated surface and, when peeled away, retained the colour of the paint in fantastically textured surfaces which could then be worked over. The surfaces themselves, like those of frottage, would suggest a direction for the finished work to take.

Collaboration was a further way to produce images which defied the rational apparatus of the artist's individual, conscious mind. Dada artists had already experimented with working collaboratively – witness Arp and Ernst's 'FATAGAGAS'. Surrealism, however, was a movement for which collaboration and collectivity were crucially important. The name of the movement itself had been coined during two separate instances of artistic collaboration (a ballet and a play), and its members included artists with widely varying methods of practice. Collaboration was at the heart of *Les Champs magnétiques* and the period of trances.

The Surrealists invented the 'cadavre exquis' or exquisite corpse, a collaborative verbal and visual game the results of which were regularly published in *La Révolution surréaliste*. Games were used by the group to catch out the conscious mind and to draw directly on the unfettered imagination. This particular game had similarities to the game of 'consequences', and resulted in a sentence or a drawing of a figure being completed on a piece of paper passed around the group. Each player contributed an element (a noun or a head, for example), folded the paper down and passed it on. The game derived its name from one particular written result: 'the exquisite corpse will drink the new wine'.

15

Exquisite Corpse 1926–7

Pen and ink, pencil and crayon on paper
36.2 × 22.9 (14¼ × 9)
The Museum of Modern Art, New York

16
Joan Miró

Love 1926

Oil on canvas
146 × 114 (57½ × 45)
Museum Ludwig, Cologne

The 'exquisite corpse' game is an example of the continuous interchange between the poetic and the pictorial which is one of the principal characteristics of early Surrealism. While experimenting with some of the techniques outlined above, Masson and Miró also pursued this interchange as a way of making Surrealist images which might unlock the secrets of the unconscious. Masson identified in his automatic drawings a physical similarity between drawing and writing. His automatic drawing is much more linear than his pre-Surrealist work, which had more of an affinity with the tightly structured surfaces of Cubism. His Surrealist drawings are free-flowing, and he himself compared the marks he made to those of

handwriting, particularly automatic handwriting where the pen or pencil is moving very fast. Masson felt that he was producing marks influenced by the appearance and experience of automatic writing, rather than its content, and he extended this idea by dropping threads at random onto paper and drawing the resulting, handwriting-like coils and curves.

Automatic writing frees words from ordinary usage. As in word association games it is the sight and sound of one word as much as its meaning which influences the choice of another. Surrealist visual artists used this characteristic of automatic writing and speaking to enable them to make images automatically, freeing the mark from its ordinary descriptive or

denotational uses. From 1925, Miró made a series of works which fused the products of verbal and visual automatism as compatible types of non-rational communication. He treated words as objects, enjoying their shape as much as their meaning, and using their shape as well as their meaning to suggest other visual marks and other words. In *Love*, for example, Miró constructs an image of love out of a combination of verbal and visual marks. One figure is represented by a simple stick person. Dangling from either the left arm or the left breast of this figure is a second figure, the literal embodiment of her love. Its body forms the letter A of 'amour', the French word for love, while the other letters cascade below in a riot of shape as well as meaning. The picture is really a 'picture poem', a picture which treats words, word fragments and letters as drawn shapes to be looked at, as well as coded messages to be looked through to the meanings they convey. The later *A Star Caresses the Breast of a Negress* uses language to lead the viewer around the image. The word star (*étoile*) is in the upper part of the picture where a star might be expected to be. The word negress (*négresse*) helps the viewer read the large form next to it as a female figure. The painted handwriting draws attention to the visual beauty of words, while at the same time the repeating 's' and 'e' sounds stress their aural elegance.

Miró's *Painting* of 1927 has a somewhat different relationship to poetry. Like *Love*, it consists of a broad field of colour, animated by enigmatic marks or signs, but this time there are no words. The shapes, however, are ambiguous. They could refer to several things at once and they seem to

function both as signals of something (denotational 'code' marks rather like words), and as simple, sensuous combinations of lines. It has been suggested that one source for the painting may have been Apollinaire's *Les Mamelles de Tirésias*, the play which gave Surrealism its name. In the play, a character called Thérèse announces that she is tired of being a woman and, rather than have babies, wants to be a man and have a job. She senses physical changes: 'My beard is growing, my bosom is coming away'. She utters a loud cry and opens her blouse, from which her breasts float out in the form of red and blue balloons. Eventually, Thérèse becomes Tirésias, a man-woman, who says he will produce babies on his own. On the right of Miró's picture is a breast-like form, which has a balloon beside it. Below the nipple is a brown patch which may be readable as a beard. There are several balls and balloons in the picture: Tirésias throws balls into the audience to represent his/her abandonment of his/her breasts. The play does not explain the picture, and the picture does

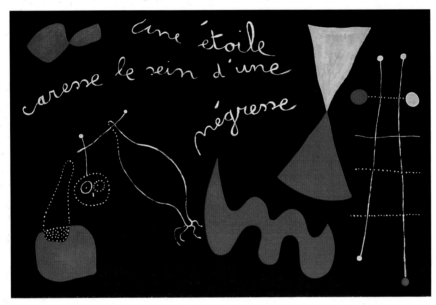

17
Joan Miró

A Star Caresses the Breast of a Negress (Painting Poem) 1938

Oil on canvas
129.5 × 194.3
(51 × 76 ½)
Tate Gallery

18
Joan Miró

Painting 1927

Tempera and oil
on canvas
97.2 × 130
(38¼ × 51¼)
Tate Gallery

not illustrate the action of the play, but the two co-exist in an imaginative, fertile relationship. Such ambiguity and possibility of meaning is the hallmark of Surrealist poetic and automatic word and picture association.

Miró's equation of words and images, his use of words as objects from which a picture may be constructed, has similarities with collage. Collage was an important Dada technique, and had been used by the Italian Futurists and Parisian Cubists before that. It was brought into Surrealism by Max Ernst, specifically by his first Paris exhibition in 1921:

> I well remember the time when Tzara, Aragon, Soupault and I first discovered Max Ernst's collages. We were all at Picabia's house when they arrived from Cologne. They moved us in a way that we were never to experience again. The external object had been displaced from its accustomed surroundings. Its separate parts had liberated themselves from the objective context in a way that enabled them to enter completely new relations with other elements (Breton in Hans Richter, *Dada: Art and Anti Art*).

For Ernst, collage was akin to frottage in that it involved 'the magisterial eruption of the irrational in all domains of art' (Ernst, *Beyond Painting*). Collages, like frottages, had their starting point outside the individual artistic imagination:

> One rainy day in 1919 . . . I was struck by the obsession which held under my gaze the pages of an illustrated catalogue showing objects designed for anthropologic, microscopic, psychologic, mineralogic and paleontologic demonstration. There I found brought together elements of figuration so remote that the sheer absurdity of the collection provoked a sudden intensification of the visionary faculties in me and brought forth an illusive succession of contradictory images, double, triple and multiple images, piling up on each other with the persistence and rapidity which are peculiar to love memories and visions of half-sleep (Ernst, *Beyond Painting*).

Ernst began to draw directly onto such catalogues, and then to cut them up. He took images from them and also from old nature and science journals, placing objects together and drawing both formal and metaphorical inspiration from the unexpected juxtapositions he created.

Breton wrote the preface for Ernst's 1921 Paris exhibition. It was his first text on art, and in it he tried to find room for the visual in the new system of thought which was to become Surrealism. He did this by equating poetry and collage, by treating words and depicted objects as similar units whose combination might reveal unconscious secrets and desires. He compared collage to the poetic metaphor – the comparison of like with unlike to achieve inspiration and understanding. 'It is the marvellous faculty of attaining two widely separate realities without departing from the realm

of our experience; of bringing them together and drawing a spark from their contact'.

This, although it was written in 1921 and in the context of Dada and not yet of Surrealism, comes close to a definition of the Surrealist marvellous and to the theory of the Surrealist image which was formulated in the 1924 manifesto and which sustained and inspired Surrealist artists and poets for several years. The theory owes something to the older poet Paul Reverdy (whom Breton admired at this point), who observed that 'the image is a pure creation of the spirit. It cannot be born of comparison but only of the coming together of two or more distant realities' (Reverdy, 'L'Image', *Nord-Sud* 13). Breton's understanding of the creativity that results from the coming together of unexpected pairs also owes much to Isidore Ducasse, the self-styled Comte de Lautréamont, a nineteenth-century poet whose work Breton rescued from obscurity by copying out the only surviving text of his *Poésies* in the National Library in Paris so that it could be reprinted for a contemporary audience. In his most celebrated work, *Les Chants de Maldoror*, Lautréamont wrote the phrase that was adopted as the paradigmatic Surrealist image, the flag which flies over all the mysterious visual and verbal combinations of Surrealist art: 'beautiful as the chance encounter of an umbrella and a sewing machine on a dissecting table'.

Max Ernst achieved this kind of Surrealist 'beauty' in painting as well as collage. From 1921 he made paintings which resemble painted collages and have become known as 'collage paintings'. These are paintings which we think of as classically 'Surrealist': they combine in bizarre and inexplicable contexts a variety of objects, each painted with a dead-pan, unremarkable, cut-out clarity. In *Celebes*, a huge 'elephant' confronts a beckoning, headless, nude female mannequin. The elephant has a horned head, but behind him is a set of tusks which suggests a second, or alternative head. True to the nature of collage, clues in the picture hinder rather than help the viewer's quest for understanding: the elephant is on solid ground, yet fish swim in the sky. The elephant is derived from two sources – one visual and one verbal. He did not originate in Ernst's mind, but already existed in the outside world and could, once 'recognised' by Ernst as a potentially fruitful image, be appropriated and elaborated upon by the artist's imagination. His shape is taken from a photograph of a Sudanese corn bin Ernst found in a magazine. His name comes from a smutty schoolboy rhyme:

19
Max Ernst
Celebes 1921
Oil on canvas
125.5 × 108
(49½ × 42½)
Tate Gallery

Der Elephant von Celebes	*The elephant from Celebes*
Hat hinten etwas gelebes	*has sticky yellow bottom grease.*
Der Elephant von Sumatra	*The elephant from Sumatra*
Der Vögelt seine Grossmama	*always fucks his grandmamma.*
Der Elephant von Indien	*The elephant from India*
Der Kann das Loch nicht findien.	*can never find the hole ha-ha.*

In 1923 Ernst painted *Pietà or Revolution by Night*. The artist was again indebted to external sources, not least for his title and for the picture's composition. The painting borrows, and parodies, traditional 'pietà' imagery. The word means 'pity' in Italian, and refers to images of the dead Christ in his

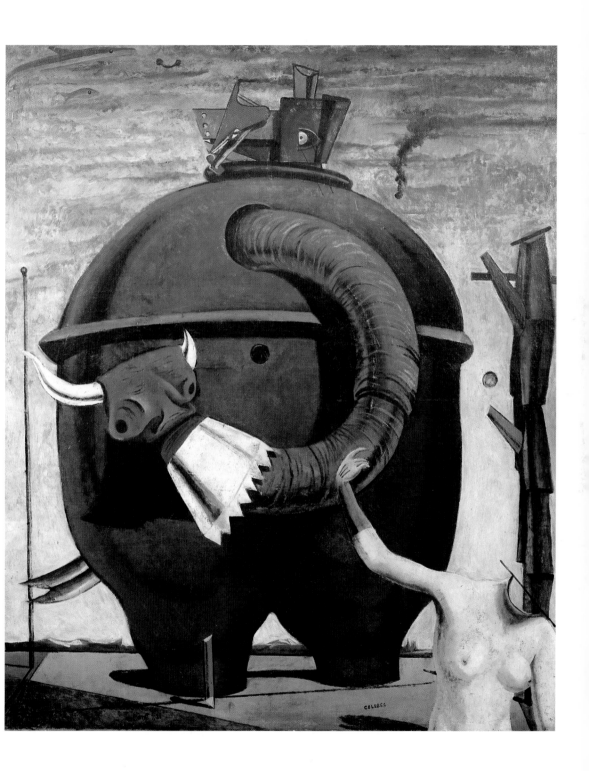

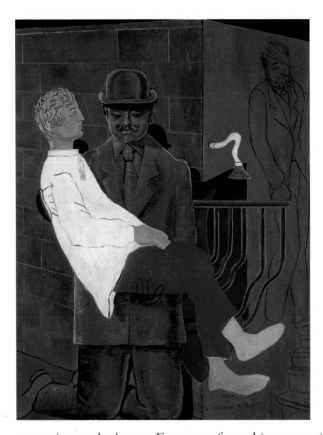

20
Max Ernst

Pietà or Revolution by Night 1923

Oil on canvas
116.2 × 88.9
(45¾ × 35)
Tate Gallery

mourning mother's arms. Ernst transforms his source with one radical substitution: the figure of 'Christ' is supported by his father rather than his mother. The father looks a little like Ernst's own father. 'Christ' is recognisably the artist himself. He is in a stiff, trance-like pose, is barefoot, and wears simple clothes. It has been suggested that in this representation of himself Ernst is referring back to a childhood escapade in which he ran away from home in his nightshirt. He encountered a group of pilgrims who compared the angelic, blond little boy to the Christ child. On his return home, Ernst's father commemorated the episode by painting a picture of the child Jesus with his son's face. In *Pietà or Revolution by Night* Ernst is once again that child, and the picture, as well as being a combination of various sources, may also perhaps be interpreted as some kind of memory, or waking dream, of that incident.

It is possible to link this painting to the writings of Sigmund Freud. Ernst is known to have read Freud's *The Interpretation of Dreams* and *Jokes and their Relation to the Unconscious* while in Germany, and Freud's writings were important to the Surrealists' explorations of the unconscious. The painting makes an oblique reference to the Freudian Oedipus complex: the desire of the developing individual to replace his father in his mother's affections and his corresponding fear of his father's (potentially castrating) anger. Ernst may be deliberately painting a version of the Oedipus complex transposed as if in a dream: Freud's theory of dreams insists that when a recognisable person appears in a dream they are usually a substitute for someone else.

Ernst's father, in the position of the Virgin Mary, may therefore be standing in for his desired (and symbolically 'virgin') mother. Ernst's own appearance as an adult in his father's arms may be a combination of his grown-up self with the situation of the small boy he returns to in his dreams.

Freud was an important factor in Breton's development of a theory of linguistic automatism. During the First World War, Breton was stationed in a hospital which treated soldiers suffering from shell shock. The doctors in the hospital used various methods of treatment, including Freudian word-association, in which patients were encouraged to respond to words suggested by the doctor, replying as quickly as possible, with the first word that came into their head. This technique influenced Breton's post-war experimental writing, such as *Les Champs magnétiques*:

> Completely occupied as I still was with Freud at that time, and familiar as I was with his methods of examination which I had some slight occasion to use on some patients during the war, I resolved to obtain from myself what we were trying to obtain from them, namely, a monologue spoken as rapidly as possible without any intervention on the part of the critical faculties, a monologue consequently unencumbered by the slightest inhibition and which was, as closely as possible, akin to *spoken thought*. It had seemed to me, and still does ... that the speed of thought is no greater than the speed of speech, and that thought does not necessarily defy language, nor even the fast-moving pen. It was in this frame of mind that Philippe Soupault ... and I decided to blacken some paper, with a praiseworthy disdain for what might result from a literary point of view (Breton, *Manifeste du surréalisme*).

Freud's writing provided Breton and Surrealism with a context and a vocabulary in which to pursue investigations into automatic speaking, writing and image-making. His work on dreams and the psycho-sexual development of the individual supported the Surrealist's quest for an art connected to the unconscious. Freud identified the dream as a means of studying the drives and desires which make up the inner life of an individual. He formed the notion of a correspondence between that inner life and the external world of language and of objects. Surrealist automatic writing and speaking mimicked the methods Freud used to get a patient to tell him their dreams. He would ask for a spoken account of a dream – a 'dream text' – in which the dream's significance for the patient's mental state would be hidden. Freud identified the strategies that a speaker might use involuntarily to disguise from themselves and from Freud the important parts of a dream. These unconscious strategies were consciously adopted by the Surrealists as a further way of painting the unconscious into their pictures, of finding a pictorial equivalent to automatic poetry.

3

21
Salvador Dalí

Metamorphosis of Narcissus 1937

Oil on canvas
51.1 × 78.1
(20¼ × 30¾)
Tate Gallery

'Images of concrete irrationality'
SURREALIST DREAM IMAGERY

The Surrealist painter most popularly associated with Sigmund Freud is Salvador Dalí. Dalí went to meet Freud in 1939, when Freud was living in exile in London. Dalí showed the psychoanalyst and writer his *Metamorphosis of Narcissus*. Freud's response to the picture was to stress the artificiality of the Surrealist attempt to recapture and recreate artistically the conditions of the unconscious mind. 'It is not the unconscious I seek in your pictures but the conscious', Freud said. He made it clear that Surrealist paintings could not be used to psychoanalyse their painters. Instead, the artists were merely using methods and motifs drawn from psychoanalysis to give their pictures a look of the unconscious.

Dalí's move from Spain to Paris in the summer of 1929 had coincided with a shift in Surrealist interest and enquiry. Although it is not possible to divide Surrealism into two stages without over-simplifying the historical situation, it is generally true that by 1929 the quest for pictorial automatism which preoccupied Surrealist painters in the 1920s had almost run its course (interest in this form of mark-making nevertheless recurred in the United States in the 1940s). Members of the Surrealist group were beginning to turn more and more to the dream as the locus of mental activity corresponding most closely to the Surrealist marvellous. This resulted in 'dream paintings', or 'oneiric paintings', as they are sometimes known: paintings which refer to or reduplicate the condition of dreaming. Dalí's arrival in Paris gave great impetus to this style of painting. He described his work as 'instantaneous and hand done colour photography of the super-fine, extravagant, extra-plastic,

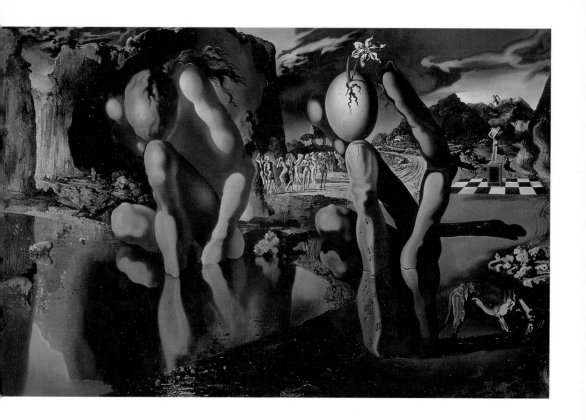

extra-pictorial, unexplored, super-pictorial, super-plastic, deceptive, hyper normal and sickly images of concrete irrationality'.

In automatic painting, the unexpected juxtapositions of the Surrealist image were supposed to arrive naturally and spontaneously on the canvas. In dream painting, the image was consciously decided upon and realistically painted. In order to 'photograph' images of 'concrete irrationality' suggestive of the dream state, the painters most closely associated with this phase of Surrealism – Dalí, Magritte, Tanguy and Ernst – used a very minutely detailed painting technique. Dream paintings owe much to collage and collage painting. Some of Ernst's collage paintings in fact have much to do with the dream, and can be seen both as precursors to other dream paintings of the 1930s, and as dream paintings in their own right. Dream paintings rely on juxtaposition for their effects, so the objects they feature tend to be painted with hallucinatory illusionism, or at least immediate recognisability. On seeing the *Metamorphosis of Narcissus*, Freud had also commented on Dalí's 'undeniable technical mastery', a comment that points up Dalí's painstaking method of making paintings which bore little resemblance to the exuberant, unconscious mark-making of Surrealist automatic imagery in the 1920s.

The work of the Italian painter Giorgio de Chirico was very influential on Surrealist painting. If Freud provided the Surrealists with the subject matter of the dream, and a hint as to its importance in an investigation of the workings of the imagination, then the metaphysical qualities of de Chirico's paintings between 1910 and 1920 provided a clue as to how a dream might

actually be painted. From 1912 to 1915 de Chirico lived in Paris and, in a hugely influential sequence of paintings, developed a way to use the traditional language of painting to describe an internally imagined world of disruption and irrational possibility. De Chirico never joined the Surrealist movement,

but its members were familiar with him and his work through exhibition and publication in periodicals. They admired the disconnected dramas played out in the deep space of paintings like *The Uncertainty of the Poet*. The world of such paintings is, like that of dreams, at once familiar and unfamiliar. Familiar because of de Chirico's minutely realist painting style which allows

the viewer to recognise objects, unfamiliar because of the strange, dream-like contexts into which he paints them. The objects in de Chirico's paintings exist in an uneasy juxtaposition; the space in which they are placed is one of quiet, forbidding uncertainty.

Oneiric paintings refer in several different ways to the nature of dreaming. Some are records of a dream actually experienced by the artist – a kind of pictorial dream work, where the painting of the picture functions like the recounting of a dream. One early example of this is Ernst's *Pietà or Revolution by Night* of 1923. This painting's combination of a kind of automatism with a concern for the dream helps to disrupt the idea of a neat division of Surrealist art into two halves determined by the decade in which it belongs. As well as memories of a childhood escapade, the painting may also have details of a particular dream deliberately embedded within it. The vision of the mahogany panel which inspired frottage is part of the account of a dream or 'fever vision' which Ernst experienced:

22
Giorgio de Chirico
The Uncertainty of the Poet 1913
Oil on canvas
106 × 94 (41¾ × 37)
Tate Gallery

> A fever vision: I see before me a panel crudely painted with large black strokes on a red background imitating the grain of mahogany and provoking associations of organic forms – a threatening eye, a long nose, the enormous head of a bird with thick black hair, and so forth. In front of the panel a shiny black man makes slow, comic, and, according to the memories of a time long past, joyously obscene gestures. This odd fellow wears my father's moustaches. After several leaps in slow motion which revolt me, legs spread, knees folded, torso bent, he smiles and takes from his pocket a big crayon made from some soft material which I cannot more precisely describe. He sets to work. Breathing loudly he hastily traces black lines on the imitation mahogany. Quickly he gives it new, surprising and despicable forms. He exaggerates the resemblance to ferocious and vicious animals to such an extent that they become alive, inspiring me with horror and anguish. Satisfied with his art, the man seizes and gathers his creations into a kind of vase which, for this purpose, he paints in the air. He whirls the contents of the vase by moving his crayon faster and faster. The vase ends up by spinning and becomes a top. The crayon becomes a whip. Now I realise that this strange painter is my father. With all his might he wields the whip and accompanies his movements with terrible gasps of breath, blasts from an enormous and enraged locomotive. With a passion that is frantic, he makes the top jump and spin round my bed.

Ernst's dream seems, among other possible interpretations, to be about his father, and about painting. His father was an amateur painter, who disapproved of his son's Dada and Surrealist ways of working. *Pietà or Revolution by Night* contains several references to the processes of making art: parts are drawn, parts are monochrome, and only some areas are completely painted.

The paintings of Dalí and Magritte make use of a restricted range of motifs which reappear again and again in each artist's work, almost like recurring dreams or nightmares. Magritte's *The Annunciation* brings together three of his favourite motifs – a curtain of iron with bell-like shapes on it, a sheet of paper cut out like a child's paper snowflake, and enlarged balusters or 'bilboquets' (Magritte's word) which turn up again and again in his pictures, plunging the viewer and the other motifs in the paintings into an Alice-in-Wonderland world of enlargement and miniaturisation.

The action of Dalí's *Autumnal Cannibalism* takes place on a table set in the middle of the plain of Ampurdàn, near Dalí's home in Catalonia. On this table, two almost human creatures eat each other, surrounded by typically Dalinian objects. The beans, crutch, apple, pieces of meat, bread and clustering ants may all be found in other paintings. In a familiar setting, from familiar objects, Dalí concocts a decidedly unfamiliar drama.

With this drama, Dalí is trying to simulate the conditions of the dream. Rather than painting any particular dream, he investigates what dreaming is like: what it is suddenly to find yourself in the middle of a world governed by the nonsensical rules of the dream. The painting sets up a scene of

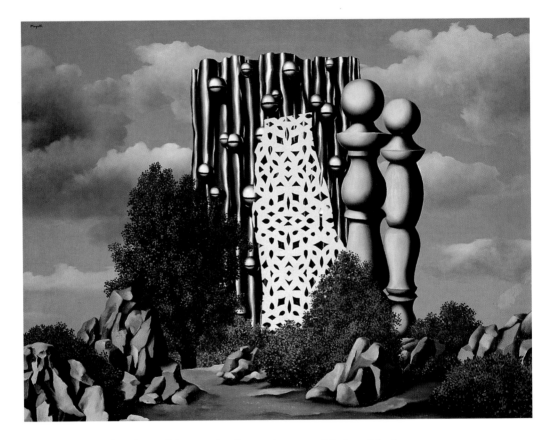

hallucination. The plain of Ampurdàn is continuous with the table the creatures are resting on: it changes scale and shape. The table also seems to merge nightmarishly with the creatures themselves. One cutlery drawer emerges from the chest of the right-hand figure. As well as reduplicating the strange metamorphoses which occur in dreams, this may also refer to another Freudian phenomenon. Believing as he did that the actual words used by a patient to recount a dream held the key to the dream's significance, Freud laid great importance on figures of speech. Dalí painted *Autumnal Cannibalism* in 1936, the year of the *International Surrealist Exhibition* in London. Conroy Maddox, a British Surrealist painter, remembers Dalí being fascinated by the evocative power of certain English expressions: chimney breast, chest of

drawers. In this painting he imagines the hallucinatory horrors that such a phrase might conceal.

Magritte's *Man with a Newspaper* sets up the kind of inexplicable narrative into which dreams translate the actions and activities of every-day lives. It is presented sequentially, as four frames of a potential story. What the story may be, however, is radically uncertain, and Magritte offers no clues. The source for the picture is in fact not a dream, but an illustration Magritte found in a book, *The Natural Method of Healing*, a popular 'new and complete guide to health', published in 1898. The focus of the illustration was the stove, which in Magritte's adaptation takes on a more and more sinister aspect as the

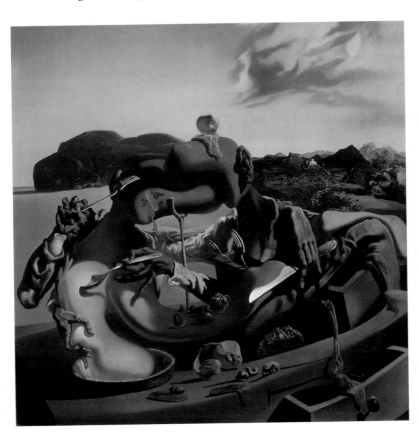

23
René Magritte

The Annunciation 1930

Oil on canvas
113.7 × 145.9
(44¾ × 57½)
Tate Gallery

24
Salvador Dalí

Autumnal Cannibalism
1936

Oil on canvas
65.1 × 65.1
(25½ × 25½)
Tate Gallery

eye moves across and down the canvas and the mind ponders the sudden disappearance or invisibility of the newspaper-reading man.

Magritte's *Reckless Sleeper* expresses a confidence in the symbolism of the dream, in its ability to express the richness of the inner world of the imagination. The picture signals an acceptance of the Freudian notion that every-day objects are transformed in dreaming into significant signs and focus points of desire and distress. Magritte paints a man asleep in a coffin-like box. Below him, set in a cloudy sky, is a grey form into which are pressed several ordinary, even banal objects. The grey form looks a little like a head, or perhaps a headstone. The suggestion is that the objects have some significance for the man, that they perhaps sum him up in some way. The painting is

ambiguous, as are dreams. It may be about death, in which case the objects function as hieroglyphic symbols on a tombstone, recapturing for posterity the details of the man's life and identity. The title tells us that it is about sleep – unquiet sleep – and thus the objects become dream objects, symbols of the reckless sleeper's innermost desires.

Although some of the objects in *The Reckless Sleeper* have Freudian connotations (the candle and the bowler hat are classic Freudian symbols for male and female sexual parts), the picture is too ambiguous simply to be 'about' one aspect of Freud's thought. Dalí's *Metamorphosis of Narcissus*, however, is intended to be directly Freudian. It is the painting which the artist showed to Freud, and it depicts the classical myth which Freud used to explain the stage in the psycho-sexual development of an individual which comes before the infamous Oedipus complex.

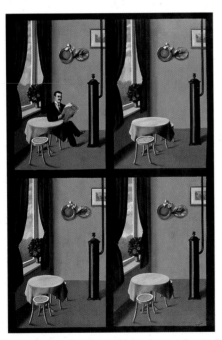

The story the painting retells is that of the youth Narcissus, turned by the gods into a narcissus flower as punishment for his self-obsession and inability to love anyone other than his own reflection in a lake. Freudian narcissism is an early stage in the formation of an individual's ego. The subject begins to be aware of their sexual drives and desires and seeks a love object. The first love object they choose is their own body. In a normal individual, narcissism should be only a passing phase, but the youth of Greek mythology was, according to the Freudian system, suffering from arrested development and could not stop staring at his own beauty looking back at him from the surface of the lake.

Dalí chose to paint the moment of Narcissus's transformation into a flower. On the left of the picture kneels a youth, looking at his reflection. As the viewer looks at this image, sorting out its rather complicated configuration of knees and elbows, it becomes obvious that it is exactly matched by an image of an enormous stone hand holding an egg from which bursts a narcissus flower. Once the eye has been drawn over the surface of the picture to examine this new shape, it is difficult to return to Narcissus without involuntarily seeing the hand and the egg superimposed on top of him. This is his fate. His punishment occurs as the viewer looks at the picture. The viewer is responsible for the metamorphosis of Narcissus.

The similarity between the figure of Narcissus and the image of the stone hand and egg makes them fuse together into a kind of double image. This was one of Dalí's gifts to Surrealism, and was the result of his famous 'paranoiac-

25
René Magritte

Man with a Newspaper
1928

Oil on canvas
115.6 × 81.3
(45½ × 32)
Tate Gallery

26
René Magritte

The Reckless Sleeper
1928

Oil on canvas
115.6 × 81.3
(45½ × 32)
Tate Gallery

critical method'. This was essentially a method for the creative misreading of the visual world. It was related to contemporary research by Freud and Jacques Lacan, the French psychoanalyst and theorist who was in direct contact with Dalí and the Surrealist group in the early 1930s. Both Freud and

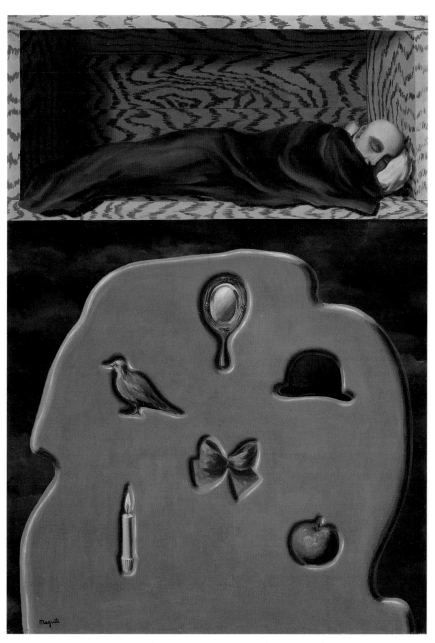

Lacan were interested in the clinical condition of paranoia, a mental illness which causes the sufferer to interpret visual information wrongly – to start 'seeing things'. In 1930, Dalí decided that he would simulate paranoia, and deliberately misinterpret what he saw, in order to use the resulting misinformation as a basis for painting. Paranoiacs are often convinced that

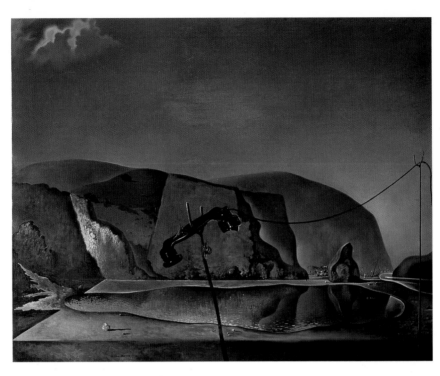

27
Salvador Dalí

Mountain Lake 1938

Oil on canvas
73 × 92.1
(28⅞ × 36¼)
Tate Gallery

28 *below*
René Magritte

The Treachery of Images
c.1928–9

Oil on canvas
64.5 × 94 (25¼ × 37)
Los Angeles County
Museum of Art.
Purchased with funds
provided by the Mr and
Mrs William Preston
Harrison Collection

29 *right*
Alberto Giacometti

Suspended Ball
1930–1

Plaster and metal
H.60 (23¾)
Private Collection

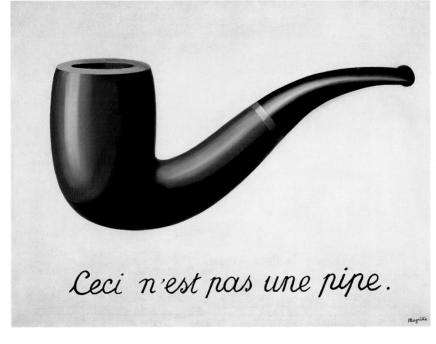

they see the same thing over and over again in different places, as they project their own mental images onto the world around them. Dalí's simulated paranoia, his paranoiac-critical method, allowed him, like a paranoiac, to re-order the world according to his interior obsessions. The boundary between the real and the imagined became ambiguous, and his pictures came to represent the space of the dream or the marvellous, a space where everything you see is potentially something else.

Dalí brought this about by introducing double images into his paintings, images which represent two or more objects simultaneously. In his *Mountain Lake*, a telephone is suspended on two crutches in front of a lake. Reflections of the rocks behind ripple and texture the lake's surface. One of them, the smallest rock, on the right of the picture, is reflected in the lake as an intense red gash. Visual concentration on this gash reveals that the lake is also the

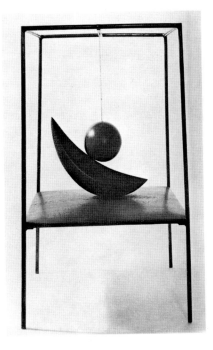

image of a fish lying on a table. The reflected rock, in this interpretation, becomes the gills of the fish, while a hitherto insignificant splash of 'water' stands in for a tail. With a little imagination, the same reflected rock can turn the fish into a penis or phallus, while the gash is readable as a vagina. As in *Metamorphosis of Narcissus*, the image undergoes a huge change of scale from lake to fish to phallus. The multiple image relies on Dalí's minutely detailed and 'realistic' technique, whereby an element overlooked in one reading of the painting – the reflection of the rock in the surface of the 'lake' – is the pivotal point of its paranoid transformation.

Surrealist paintings tend to be object based. In order to discredit and destabilise perceived normality, Surrealist artists manipulated recognisable objects, blurring the boundary between the real and the imaginary. Thus, Magritte's *The Treachery of Images* confronts the viewer with an illusionistic pipe. At the same time, the picture's caption denies that it is a pipe. A brief moment of disorientation ensues until the contradiction is resolved – it is not a pipe, but rather a painting of a pipe. Neither the image nor the caption is lying to the viewer. The painting does, however, act out the warning implied by its title: the image is so illusionistic that it is treacherous, making us 'see' something (a real pipe) that is not really there. Perhaps even real pipes are treacherous. The painting makes us doubt that we can rely on our perception of things.

A notion of objects as untrustworthy is of course central to Surrealism: the marvellous, the dream and the unconscious mind are all places of incipient metamorphosis where objects, symbols of irrational desires, are subject to sudden mutation. Dalí's double images are supremely expressive of this and are linked to his second major contribution to Surrealism – his formulation of a theory of the Surrealist object. Surrealist objects were, like the double images of Dalí's paranoiac-critical method, the result of the projection onto the outside world of the innermost thoughts and desires of

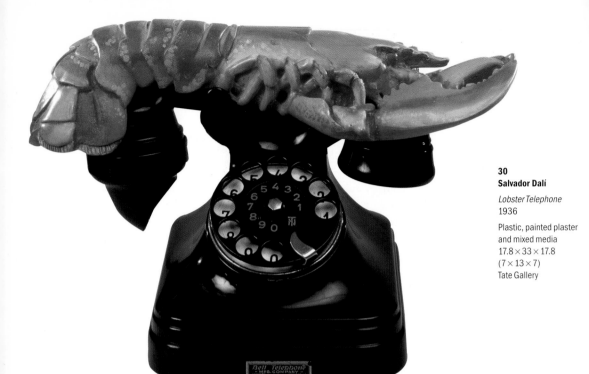

30
Salvador Dalí

Lobster Telephone
1936

Plastic, painted plaster
and mixed media
17.8 × 33 × 17.8
(7 × 13 × 7)
Tate Gallery

the artist. As early as 1924, in his *Introduction au discours sur le peu de réalité*
(*Introduction to the Discourse on the Paucity of Reality*) Breton described objects
invented whilst dreaming:

> Recently, while I was asleep, I came across a rather curious book in an open-air
> market near Saint-Malo. The back of the book was formed by a wooden gnome
> whose white beard, clipped in the Assyrian manner, reached to his feet. The book
> was of ordinary thickness, but didn't prevent me from turning the pages, which
> were of heavy black cloth. I was anxious to buy it and, upon waking, was sorry not
> to find it near me. It is comparatively easy to recall it. I would like to put into
> circulation certain objects of this kind, which appear eminently problematical
> and intriguing.

By 1935, the ambition Breton had for such objects had expanded: 'The goal
I pursued was no less than the objectification of the activity of dreaming, its
passage into reality' (Breton, *La Crise de l'objet*).

Although the Surrealist object as such was 'invented' and formalised by
Dalí, its history really begins with Giacometti, the Swiss sculptor associated
with the Surrealist movement between 1930 and 1935. Giacometti insisted that
sculpture was a projection of desire rather than the result of any formal or
aesthetic manipulation of material. He said of his Surrealist work that 'the
sculptures presented themselves to my mind entirely accomplished'. Like the
object in Breton's dream, Giacometti's sculptures came to him from his
unconscious, rather than his conscious mind and, as in the Surrealists' early
experiments with pictorial automatism, he used chance as a way to tap into his
unconscious. In *L'Amour fou* (*Mad Love*), Breton recalls how Giacometti once
found a mask in a flea market. The mask solved a problem Giacometti was

31
Meret Oppenheim

Object (Fur Breakfast)
1936

Fur-covered cup, saucer
and spoon
7.3 × 23.7 (3 × 9¼)
The Museum of Modern
Art, New York

having with the head of his sculpture of a woman called *Invisible Object*. It appeared to him as exactly the 'right' form to use to complete the sculpture. Breton felt that Giacometti was projecting his desire to solve his sculptural problem onto the objects on the market stall. The mask's appearance was an example of 'hasard objectif' or objective chance – a coincidence manipulated by the unconscious mind.

In 1930 Giacometti made *Suspended Ball*. A ball with a slit in it, suspended over a wedge shape, it is a sculpture which calls out for the participation of the viewer. The ball begs to be swung over and along the wedge, trailing ambiguous sexual metaphors as it goes. The sculpture seems to be about desire and the frustration of desire: the viewer cannot push the ball, and the ball does not anyway quite fit over the wedge. In December 1931, Breton published *Suspended Ball* in issue three of *Le Surréalisme au service de la révolution*, as part of Giacometti's essay 'Objects mobiles et muets' (moveable and silent objects). This was immediately preceded by Dalí's 'Objets surréalistes' (Surrealist objects) in which he offered a catalogue of the Surrealist object directly inspired by *Suspended Ball*.

In his article, Dalí, in deliberately impenetrable, 'Dalinian' language, identifies six categories of the Surrealist object: the object of symbolic functioning (automatic origin); transubstantiated objects (affective origin); objects to project (oneiric origin); wrapped objects (diurnal fantasies); machine objects (experimental fantasies) and moulded objects (hypnagogic origin). Dalí only discusses his first category, in which he places *Suspended Ball*: 'a ball of wood marked by a female groove suspended by a violin string above a crescent whose sharp edge skims the cavity. The spectator instinctively wishes to slide the ball along the ridge, which the length of the string only partially permits'. He also discusses several other objects made by members of the Surrealist group (himself, Breton, his wife Gala and Valentine Hugo) as similarly 'based on the phantasms and representations susceptible of being provoked by the realisation of unconscious acts'.

Dalí's categorisation and classification of the Surrealist object unleashed a torrent of creativity, culminating in an exhibition at the Galerie Charles Ratton in 1936. Surrealist objects tended to rely on assembly more than craftsmanship and, being easily made, were a creative endeavour which united the group and attracted new collaborators. At their best, the objects combined the wit of Duchamp's 'readymades' (see p.14) with the unexpected and sometimes unsettling insight of exquisite corpse figure drawings. Dalí's own *Lobster Telephone* of 1936 plays on the untrustworthiness of objects introduced in Magritte's *The Treachery of Images*. Noticing certain similarities between a telephone receiver and a lobster – they are the same shape, have a similar texture, and make the same squealing noise when roused (or cooked) – Dalí substituted the second for the first. The resulting object, while amusing, suggests that we may be foolish to take for granted the inanimate innocence of our telephones.

The telephone hints at a narrative. Its effect comes from a realisation of what it would be like to pick up the 'receiver'. The most famous of all Surrealist objects has a similarly time-based and narrative implication: Meret Oppenheim's *Fur Breakfast* is a beautiful, tactile thing which begins to mobilise ambiguities of desire and distrust when the viewer imagines using it, raising the cup to their lips. Oppenheim reinvents a mundane, familiar object as an erotic fantasy of oral and vaginal sexual pleasure. In cladding a teacup and saucer with fur, she makes a fetish object.

A fetish is either an object believed to possess a magical power, or an object which has taken on an exceptional erotic significance for a particular individual. Fetishism thus encompasses both cultural and psycho-sexual observation and speculation, and was much discussed in Europe in the early part of the century. The Surrealists knew of it through their interest in the art and society of 'primitive peoples' as well as through their reading of Freud. Breton used the term rarely but he did use it in the context of the Surrealist object, which Dalí also described in fetishistic terms, as being a device which enabled people to touch and manipulate their 'phobias, manias, feelings and desires'.

A complex and ambiguous concept, the fetish occupies a place on the boundary between dream and reality, imagination and experience. In cultural terms, it is a link between the European and the primitive or 'other'. The 1920s and 1930s saw colonial expeditions into African territories which brought back artefacts exhibited in Paris as objects mid-way between sculptures and curios. Many of these were fetishes in a purely cultural sense, that is objects of worship or of magical power for their original owners, but they also operated as pseudo psychoanalytic fetishes: objects onto which could be projected a European romanticisation of the cultures from which they came. The

Surrealists in general disapproved of colonial activity (the group published a tract entitled *Ne visitez pas l'exposition coloniale* (*Do not Visit the Colonial Exhibition*) on the occasion of the Great Parisian Colonial Exhibition of 1931. They were, however, fascinated by non-European cultures and the objects they produced as potential sources for the marvellous – objects produced without the curse of Western sophistication and rationality. Although it was Bataille who, in his review *Documents,* published the most thoughtful and insightful ethnographic articles, Breton and his fellows were great collectors and investigators of African and Oceanic objects.

An awareness of the psychoanalytic implications of the fetish came to Surrealism through the work of the nineteenth-century psychologist Alfred Binet as well as from Sigmund Freud. Binet felt that 'everybody is more or less fetishist in love', and discussed the fetish as the physical embodiment of a mental obsession or desire. This becomes abnormal, or pathological, when, frustrated in (or even unaware of) a sexual desire, an individual diverts this desire onto an inanimate object, item of clothing or part of the body, most usually hands, feet, hair or eyes. In the Freudian system, a fetishist suffers from a perversion or diversion of the sexual drive. A traumatic early realisation of sexuality (brought about, Freud claimed, by the shock of the discovery of the absent maternal penis) causes the fetishist to become fixated on a material substitute for a secretly desired individual.

It is the fetish, therefore, that supports both the 'alien' and the sexual nature of the Surrealist object. Into the spaces of waking reality, the object inserts material evidence of the dream as unknown territory, fraught with psycho-sexual possibility. Surrealist objects are odd, disorientating and often vaguely (or specifically) sexually disturbing. Playing with the fetish as a realisation or manifestation of desire, Surrealist artists sometimes pushed this one stage further to literalise the implications of fetishism itself. For example, the fetishist may become fixated on a fragment of the desired individual's anatomy. Fragmentation is close to dismemberment, and several Surrealist objects feature severed arms or hands, wrenched from the body in a violently imagined past narrative. Hans Bellmer (who was a member of the Surrealist group from 1933 but who did not come to Paris to work until 1938) developed both the fragmentation and the substitution or displacement embedded within the fetish and the Dalinian Surrealist object. He made for himself an artificial adolescent girl: 'I shall construct an artificial girl whose anatomy will make it possible to recreate physically the dizzy heights of passion and do so to the extent of inventing new desires'. A work derived from his *Doll* was shown at the exhibition of Surrealist objects at the galérie Charles Ratton in 1936 as *Jointure de boules.* It consisted of a pair of wooden doll's arms, ball-jointed at the elbows and wrists, and joined at the shoulder so as to suggest a pair of legs. In this joint, where a vulva might be expected, was a glass eye. Bellmer's *Doll* was a woman both reduplicated and dismembered, reassembled as a manifestation of Bellmer's deliberately perverted desire.

32
Hans Bellmer

The Doll 1936/65

Painted aluminium on brass base
46.4×26×22.9
(18¼×10¼×9)
Tate Gallery

4

33
René Magritte

The Hidden Woman

Reproduction
surrounded by
photographs of the
Surrealists, *La
Révolution surréaliste*
no.12, December 1929

'Je ne vois pas la femme'
WOMEN IN SURREALISM

In December 1929, the last issue of *La Révolution surréaliste* illustrated, in the middle of an enquiry into 'what kind of trust do you place in love?', a photomontage combining Magritte's painting *La Femme cachée* (*The Hidden Woman*) with mugshots of the male Parisian Surrealists. The canvas is inscribed along the top 'Je ne vois pas la' and along the bottom 'cachée dans le forêt' (I do not see the ... hidden in the forest). In between there is a standing female nude. The artists all have their eyes closed: they do not see the woman, who is hidden in the title of the painting but clearly visible to the reader of the magazine who is invited to fill in the gap in the inscription. The fact that the men all have their eyes closed suggests that they are in a state of trance or dream, that they are in communication with their interior selves rather than making contact with the reader. The woman looks away, and a series of oppositions is set up between her and the men: they are many, she is one; they are clothed, she is naked; they are recognisable individuals, she is undifferentiated, a generic 'woman'.

34
Alberto Giacometti

Walking Woman
1932–3/1936, cast
1966

Bronze
149.9 × 27.6 × 37.8
(59 × 11 × 15)
Tate Gallery

This image forms a companion to one from the first issue of *La Révolution surréaliste* which combines a photograph of Germaine Berton with similarly scaled portrait shots of the members of the Surrealist group. Berton was an anarchist who assassinated Maurice Plateau, a leader of the Catholic *Action française* group. The Surrealists celebrated her as a disruptive force, and captioned her image with a quotation from the nineteenth-century poet Charles Baudelaire: 'Woman is the being who projects the greatest shadow or the greatest light into our dreams'.

In both these images, woman is presented as being in closer touch than man with the desired irrationality of the dream. The implication of the later image is that the men are searching for the woman, following her as she turns away into the creative 'forest' of the marvellous. The men are all writers and artists and so the woman, concealed as she is within a verbal and visual game, functions as a muse who might lead the men towards artistic creativity. In French, a gendered language, she is present, if camouflaged, in the inscription alone — 'la cachée' implies a hidden femininity.

The Surrealist muse has several incarnations. Women were welcomed into the movement: as lovers, friends, participants in games and collaborative image-making sessions and, from the 1930s, as artists. However, the founder and best-known members of the group were men and, artistically, their attention tended to be focused on 'woman' rather than women. Women joined the movement – Eileen Agar, Leonora Carrington, Ithell Colquhoun, Leonor Fini, Valentine Hugo, Frida Kahlo, Lee Miller, Meret Oppenheim, Dorothea Tanning, Toyen and Remedios Varo were all associated with the movement from the later 1930s – but from the beginning Surrealism looked to exploit as well as support them.

One of the most visually striking manifestations of this is the popularity of the mannequin, an image which came into Surrealism through the work of de Chirico and was widely painted and sculpted as a figuration of woman as muse. Headless (and therefore 'marvellously' creative, free from the constraints of rationality, 'out of her head', even), often armless and ultimately manipulable, the presence of the mannequin in Surrealist imagery evidences the artists' Pygmalion-like obsession with woman as a perfect being who could bring them closer to their hearts' desires. Giacometti's *Walking Woman* is a bronze cast of a plaster sculpture called *Mannequin* which originally had two outstretched arms – one ending in a bunch of feathers, the other in a flower-like hand – and a head made from the scroll of a cello. Giacometti removed the sculpture's arms just before showing it in London in 1936. The woman is walking, again leading both her creator and the viewer towards the desired marvellous – a state beyond or outside the tyranny of the rational mind.

35

Cover of *La Révolution surréaliste* nos.9–10, October 1927

In 1938, visitors to the *International Surrealist Exhibition* in Paris were ushered into the presence of the Surrealist imagination by a long line of shop mannequins, each dressed and distorted by a different artist. The Surrealist mannequin is closely related to the doll – the dolls of Bellmer's nastily imagined 'ideal' adolescent femininity, fetish dolls and children's toys. The Surrealist muse was herself something of a doll: Breton's ideal of femininity was the 'femme-enfant' or child-woman. Combining two beings with privileged access to the marvellous, the femme-enfant, young, naïve and in touch with her own unconscious, was a role which could be adopted by, or thrust upon, real as well as imagined women. In 1927 a femme-enfant appeared on the cover of *La Révolution surréaliste*. In a school uniform, at a child's desk, she takes dictation from her own or someone else's imagination. The following year, Breton met Nadja.

Nadja was the archetypal femme-enfant. A real young woman whom Breton pursued and loved, she was the subject of his book *Nadja*, a novel which is ostensibly about their brief relationship (which ended with Nadja being institutionalised for mental illness). In reality, however, the book is about Breton's quest for self-knowledge and creative freedom through his liaison with Nadja. A muse, in helping a writer unleash his creativity, also helps him find himself. Nadja had clairvoyant powers; according to Breton she had 'passed through to the other side of the mirror', and he wanted to join her there. The book is much more about him than it is about her: narrated by Breton in the first person it begins 'Who am I?' and ends with a photograph of the author. Although Nadja actually existed, the reader knows her only as an artificial, textual reconstruction of herself. She is a catalyst, a pretext for writing, a muse. As 'her' story unfolds, the reader knows less and less of Nadja, and by the end she seems only to have been the figment of the imagination she has been instrumental in unlocking. Rather than reality, she inhabits only the marvellous.

36

Marble relief. Vatican Museums

37 *right*
Salvador Dalí

My Wife, Nude, Watching her own Body become Steps, Three Vertebrae of a Column, Sky and Architecture 1945

Oil on wood
61 × 52 (24 × 20½)
Private Collection

A Freudian addition to the Surrealist understanding of woman as a muse with a duty of revelation came from Freud's published analysis of the German short story *Gradiva: A Pompeiian Fantasy* by Wilhelm Jensen. In the story, Gradiva is a girl pictured on a Greek stone relief with which Norbert Hanold, a young archaeologist, is obsessed. Hanold becomes fixated on Gradiva's gait as it is represented on the relief, and he calls her the girl 'splendid in walking'. Hanold dreams that Gradiva was buried alive in the

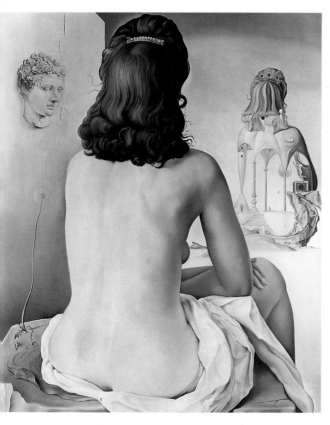

wreckage of Pompeii, and he travels there to see if he can find any traces of her. Once in Pompeii, he meets a girl, also 'splendid in walking', who he is convinced is Gradiva or her reincarnation. She is in fact a long-abandoned childhood sweetheart, Zoë Bertgang. Once Hanold realises this, he is cured of his obsession with the Greek relief and is free to live normal life with Zoë. Freud points out that Bertgang in German means 'splendid in walking'. He concludes that Hanold has been obsessed with Zoë all along, and that meeting her has released his repressed desire.

Zoë-Gradiva is a femme-enfant. She combines elements from womanhood and child-hood, and her role is to help Hanold solve the mysteries of his unconscious. She is a site of exchange between dream and reality and, as such, was venerated by the Surrealists. In 1937 Breton opened the Gradiva gallery, with a pamphlet dedicated to the ideal of Surrealist child-womanhood:

> From the book of children's images to the book of poetic images
> GRADIVA
> On the bridge which links dreaming to reality . . .
> GRADIVA
> On the borders of utopia and truth — truly alive
> G R A D I V A
> like
> Gisèle, Rosine, Alice, Dora, Iñes, Violette, Alice

In Surrealist terminology, Gradiva became 'she who advances' because of Hanold's obsession with the way she walked, and because the Surrealists saw her as a woman who leads Hanold forward towards self-discovery. Her gaze was strong enough to pierce the walls which, in the story are symbols (Hanold is, after all, an archaeologist) for the defences the adult builds against the repressed wishes and desires of childhood.

Salvador Dalí had his own Gradiva, his wife Gala: 'Gala is trinity. She is Gradiva, she who advances. She is, according to Paul Eluard, the woman whose gaze pierces walls'. Dalí met Gala when she was still married to the poet Paul Eluard, in the summer of 1929 when the couple visited him in

Spain. Like Hanold, Dalí claimed that he 'recognised' in Gala a reincarnation of a childhood friend: 'Gala, Eluard's wife. It was she! I had just recognised her by her bare back'.

Gala became Dalí's wife and his muse. He painted her obsessively, absorbing her into his world of dream imagery and testing out his 'paranoiac' ideas on her well-known and well-loved form. Her bare back, in particular, became a vehicle for experimentation. In 1945 he painted *My Wife, Nude, Watching her own Body become Steps, Three Vertebrae of a Column, Sky and Architecture*. Much like Breton's Nadja, Gala also became an instrument through which Dalí might gain self-knowledge, belonging so completely to his iconography that her appearance in a painting is as much a symbol of him as a representation of her. In the poem which Dalí wrote to accompany *Metamorphosis of Narcissus* he identifies Gala as himself:

When that head slits
when that head splits
when that head bursts
it will be the flower,
the new Narcissus,
Gala —
my Narcissus.

Gala was not herself an artist. A strong, intelligent woman, she was, however, fully complicit in Dalí's manipulation of her image. She participated in his Surrealist games and flamboyant excess, and she managed his finances. She has even been blamed for Dalí's transformation into 'Avida Dollars', Breton's anagrammatic name for the artist's post-war, money-grabbing, American persona. The kind of metamorphoses practised by Dalí on Gala's body were, however, ripe for reclamation by other, female, artists.

In 1938, for example, Ithell Colquhoun painted *Scylla*. Like *Metamorphosis of Narcissus*, the painting refers to a Greek myth. Scylla was a nymph who lured sailors towards dangerous, clashing rocks on the Italian side of the Straits of Messina. The painting shows the rocks with a boat coming towards them. But *Scylla* is a double image, and the artist wrote that it 'was suggested by what I could see of myself in a bath'. This demands a change of scale and narrative implication: the twin rocks become knees, ready to clash together at the approach of the threatening, phallic boat and the painting becomes a powerful reassertion of a woman's right to her own body. Although we only see part of the body in *Scylla*, this is because of the artist's own physical view of herself and not as a result of any fetishistic or idealistic displacement of male desire.

Between 1934 and 1936 Eileen Agar, another British artist, made *Angel of Anarchy*. It was lost, so she made a second and different version (fig.39). This assemblage re-works, from a female perspective, the paradigm of woman as

muse with privileged access to both her own and her manipulator's unconscious. Agar's angel is blinded, a traditional 'seer', seeing only the images of the imagination. It is gorgeously dressed in richly textured materials but, crucially, is not female. The head was cast in plaster from a clay portrait bust of Joseph Bard, the Hungarian poet Agar later married. The object's title refers to Herbert Read, the critic partly responsible for bringing Surrealism to Britain. Agar wrote that 'the title was suggested by the fact that Herbert Read was known to the Surrealists as a benign anarchist'.

The women actively involved in Surrealism were introduced to the movement through personal contact with its existing members, and through exposure to their increasingly visible art. Throughout the 1930s several women came to Paris to live and work, contributing to the daily life, iconography and ideology of Surrealism, and also, by returning home or moving on, to the

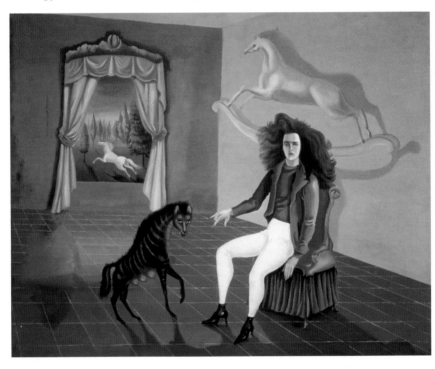

40
Leonora Carrington
Self Portrait c.1938
Oil on canvas
50.2 × 26.7
(19¾ × 10½)
Mallin-Young Archive
Collection

41
Leonora Carrington
Portrait of Max Ernst c.1939
Oil on canvas
50.2 × 26.7
(19¾ × 10½)
Brewster Arts Ltd

movement's expansionist ambitions. The Spanish artist Remedios Varo, for example, met the poet Benjamin Peret in Barcelona, where she had moved in search of the artistic avant garde. She moved with Peret to Paris and, with the outbreak of the Second World War, to Mexico where the couple were at the centre of a group of exiled Surrealist artists. The Czechoslovakian artist Toyen came to Paris for three years in 1925. Returning to Prague, her work came closer to Surrealism, her paintings floating strange, often sexually provocative motifs against seemingly automatic, abstracted backgrounds. With the painter Styrský, she founded a Czech Surrealist group in Prague, before being forced by the German occupying forces to flee back to Paris in 1947.

Leonora Carrington, an English painter and writer, was given Herbert

Read's book *Surrealism* in 1936. Captivated by Ernst's paintings reproduced in the book, she met him at the opening of his exhibition at the Mayor gallery in London in 1937 and moved with him to France. They stayed together until the outbreak of the Second World War, and Carrington began to paint and write in a Surrealist manner. She produced two paintings which express both her relationship with Ernst and her personal re-working of the possibilities of the Surrealist imagination: *Self Portrait* and *Portrait of Max Ernst*. In *Self Portrait*, Carrington paints herself in a room full of the irrationally creative potential of the marvellous. The Victorian chair on which she sits has human hands and feet at the end of its 'arms' and 'legs'. She is approached by a multi-breasted hyena, magically conjured from a puff of smoke. Behind her floats a dematerialised rocking horse, matched by the horse who gallops away from the open window. Animate and inanimate merge in this painting, and the space it depicts is mid-way between dream and reality. Recognisably Surrealist, it is also a space of self-exploration, a space on the boundary between adult knowledge and childish quest. As a child, Carrington enjoyed an imaginary friendship with a toy rocking horse and in her story *The House of Fear*, written in 1937, the horse appears as her alter-ego, a friendly spiritual guide, leading the heroine of the story into a world of mystery and transformation governed by the figure of Fear. Fear is eventually banished by the birdman Loplop, the alter-ego of Max Ernst. Ernst wrote an introduction to Carrington's story, and made collages with which to illustrate it. Carrington's *Portrait of Max Ernst* recreates the male artist as a mystical figure of transformation and rescue. Bird-like and also fish-like, Ernst is a vivid splash of colour, capable of liberating and reviving both the frozen horse behind him and the one trapped in the glass of the lantern he carries. If the bird and the horse may be read as totemic substitutions for Carrington and Ernst, the picture perhaps reverses conventional Surrealist male/female behaviour: Carrington may be claiming Ernst as her 'muse'.

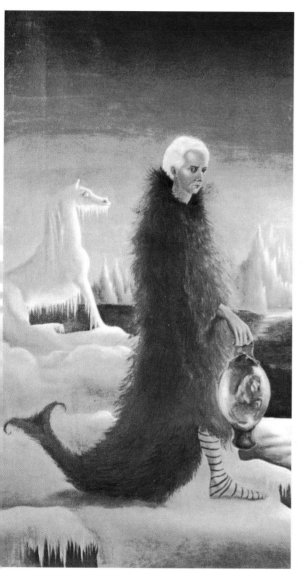

5

'What then is this Surrealist activity or Surrealism?'
SURREALISM IN ENGLAND AND AMERICA

In 1932, Edward W. Titus, the editor of the English periodical *This Quarter*, attempted to answer this question, posed by himself in response to the overwhelming enthusiasm for Surrealism expressed among Parisian college students and reported in the French daily newspaper *L'Intransigeant* (*The Intransigent*). Titus invited André Breton to edit a special edition of his periodical so that the 'English speaking world' – Britain and the United States – could judge the movement for itself. Titus attempted an introductory definition: 'Surrealism consists of the cultivation and practice of communicating the unconscious by writing, painting, sculpture and other means'.

Breton began the issue with his own 'Surrealism Yesterday, To-day and To-morrow', in which he summarises the Surrealist intellectual revolution from its origins in Dada before the writing of the 1924 manifesto. His essay starts with a quotation from Lautréamont which is clearly intended to inspire: 'At the time of this writing new shivers are running through the intellectual atmosphere: it only needs courage to face them'. Breton gives Surrealism an English heritage, claiming Lewis Carroll, Swift, Synge and the Gothic novelists as Surrealist before the fact, much as he had done with Lautréamont and the poet Rimbaud in France. Quoting his own *Manifesto,* Breton issues English instructions for the practice of automatic writing:

> Having settled down in some spot most conducive to the mind's concentration
> upon itself, order writing material to be brought you. Let your state of mind be

as passive and receptive as possible. Forget your genius, talents, as well as the genius and talents of others. Repeat to yourself that literature is pretty well the sorriest road that leads to everywhere. Write quickly without any previously chosen subject, quickly enough not to dwell on, and not to be tempted to read over, what you have written.

Breton's summary of the history of Surrealism includes its more turbulent moments. His article makes reference to the schisms of 1928 and 1929, when the unity of the movement was threatened by Georges Bataille and the rival group he gathered around the publication *Documents*: '[Surrealism] did not shrink from disqualifying and severing relations with, all those who wanted to be content with that minimum of common activity which could be innocuously practised in literature and art'. Breton's *Seconde manifeste du surréalisme* detailed some of the circumstances of these disqualifications. In it, Breton disassociated the movement from the work of Bataille, Antonin Artaud, Masson (who later came back into favour) and Soupault. In 'Surrealism Yesterday, To-Day and To-Morrow', Breton also mentions the political crisis within Surrealism precipitated by Aragon's poem *Front Rouge* (*Red Front*). Surrealism had always had an uneasy relationship with the French Communist Party. Although itself revolutionary, Surrealism was concerned with the spiritual and emotional rather than the material, and Breton, although briefly a member of the Communist Party, found it difficult to reconcile the two. In the early 1930s, Surrealism began to be pursued along two different paths – one of political commitment and activity and one of the continued exploration of the unconscious. The split came to a head and

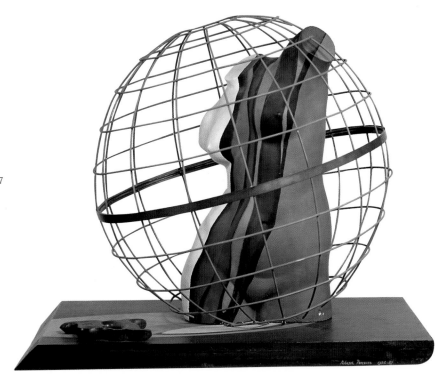

42
Roland Penrose

The Last Voyage of Captain Cook 1936/67

Painted wood, plaster and steel
69.2 × 66 × 82.5
(27¼ × 26 × 32½)
Tate Gallery

out in the open when Aragon, attending the Second International Congress of Revolutionary Writers in Karkhov, failed to defend the 'Surrealist line' as set out by Breton. Aragon instead participated in a general denunciation of idealism and Surrealism and committed himself to a 'general' or Marxist line. Back in Paris, he published the poem *Front Rouge* as proof of his revolutionary credentials. He was accused of anti-governmental activity, and Breton came publicly to his defence. But Breton disliked the poem, and mistrusted Aragon's motives for writing it. Eventually, Aragon renounced Surrealism in order to become a 'proper' communist.

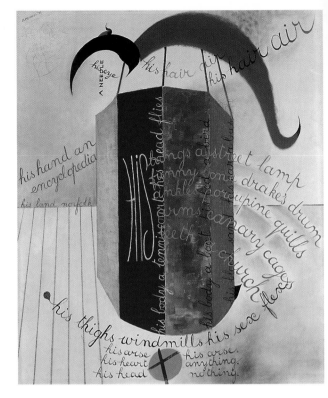

This Quarter could only offer Breton the guest editorship of their periodical 'so long as he eschewed politics and other topics as might not be in accord with Anglo-American censorship usages', and so he glossed over much of the detail of Surrealism's political and revolutionary position, complaining that the English had given him the opportunity to make himself heard 'only in undertones'. However, he appealed for a resurgence of Surrealist resistance to such small-mindedness:

> In the meantime, it does not at all appear to us impractical to organise in the four corners of the earth a fairly extensive scheme of resistance and experiment. This plan, as regards its modes of application, cannot be settled until there has been an interchange of the innermost desires of the live youth of all countries, and an estimate of the subversive forces which may be unleashed when it shall be applied at one given point. Owing to insufficient space at our disposal, this plan can only be barely hinted at. But beware! Enough if Surrealism is restored to its true perspective, and we shall not despair of seeing some day a storm rising from within this tea-cup.

To encourage this, Breton included in his issue of *This Quarter* enough material to provide the English speaking world with a kind of manual of Surrealism. Dalí's *The Stinking Ass* explains the paranoiac-critical method and the double image. Ernst's *Inspiration to Order* introduces the reader to collage, frottage, the exquisite corpse and the Surrealist object, and is supported by Dalí's *The Object as Revealed in Surrealist Experiment*. Prose and poetry by Breton, Péret, Eluard and Crevel complement drawings by de Chirico, Man Ray and Ernst.

The success of the Surrealist issue of *This Quarter* was followed in 1936 by the first *International Surrealist Exhibition*, held in June and July at the New

Burlington Galleries in London. The exhibition was seen by 25,000 people. At the opening, traffic in central London was brought to a standstill. Although de Chirico, Ernst and Dalí had all already had solo exhibitions in London, this was the first time that British artists and the general public were able to experience the full visual impact of Surrealism. The exhibition was made possible by a series of links established between French and English artists. Roland Penrose moved to Paris from Britain in the early 1920s, and there developed a fully Surrealist way of working. His *Portrait* of 1939 owes much to Miró in its combination of marks which are both representations of, and a kind of shorthand for objects. The portrait is built primarily from words, hand-written so that they catch a viewer's eye as painterly as well as literary gestures. Straight, parallel lines establish space and place – 'his land Norfolk' –, denoting furrows in a ploughed field. On this field sits the man, 'his thighs windmills his sex flex'. Rhymes force the viewer to look at and listen to the form of the words and delay a search for their conventional meaning.

In 1935, Penrose returned to England. The same year, David Gascoyne announced (unilaterally) the formation of an English Surrealist group in an article in the French *Cahiers d'art*, and published his book, *A Short Survey of Surrealism*. Gascoyne and Penrose had met in Paris and together formed the idea of bringing an exhibition of Surrealist art to London. The *International Surrealist Exhibition* was the first of a series, and part of the French Surrealists' plans for expansion. The exhibitions all followed a similar pattern: representatives of the French group would, in the company of local sympathisers, contact artists in the area of the planned exhibition. A selection would be made which combined local work with work imported from France and other countries. At the New Burlington Galleries, there were three hundred paintings, sculptures, objects and drawings made by artists from fourteen countries. On the organising committee were Roland Penrose, Herbert Read (whose book *Surrealism* was published the same year), Henry Moore, Paul Nash and, in an advisory capacity, the anglophile Belgian E.L.T. Mesens, who in 1938 moved to London to start the London Gallery. Paris was represented by Breton, Eluard, Man Ray and Georges Hugnet.

There had been no Dada in England, and although some artists, such as Wyndham Lewis, had had a lot of contact with Dada and Surrealism abroad, several of the artists who exhibited in the *International Surrealist Exhibition* became 'Surrealists

43
Roland Penrose

Portrait 1939

Oil on canvas
76.2 × 63.7 (30 × 25)
Tate Gallery

44
Eileen Agar

Marine Object 1939

Mixed media
42 × 34 × 23
(16½ × 13½ × 9)
Tate Gallery

overnight' as the organising committee detected hitherto unimagined
Surrealist influences in their work. Conroy Maddox, now one of the best-
known British Surrealist artists, refused to take part. Maddox had discovered
Surrealism in a book in the Birmingham City Library in 1935. He began to
experiment with automatism, and invented 'écrémage', a new, semi-automatic

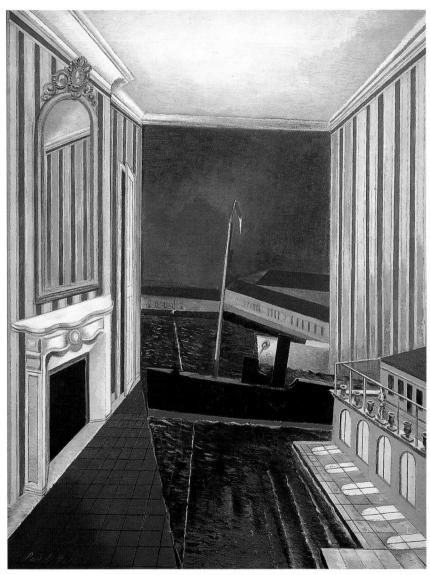

45
Paul Nash

Harbour and Room
1932–6

Oil on canvas
91.4 × 71.1 (36 × 28)
Tate Gallery

46

Salvador Dalí pictured
in a diving suit at the
*International Surrealist
Exhibition* in London,
1936. Seated next to
him are Diana and
Rupert Brinton Lee, and
in front, Paul Eluard,
Nush Eluard and E.L.T.
Mesens.

technique involving skimming paper over water in which oil paint had been
floated. He found kindred spirits in John and Robert Melville, a painter
and writer respectively. They introduced Maddox to Zwemmer's bookshop
in London where he was able to buy Surrealist literature, and they stood firm
with him against the seductive 'fraud' of the first *International Surrealist
Exhibition*:

Invited to exhibit in the *International Surrealist Exhibition* in London, I refused, and with Robert and John Melville, wrote a letter in which we drew attention to the fact that the British participation in this show was mainly made up of artists, who in their day-to-day activities, professional habits and ethics could be called anti-Surrealists ... The effect of their contribution was to dilute rather than affirm Surrealist principles, and they were led by Herbert Read who saw the movement as merely a continuation of the English romantic tradition.

Nevertheless, the exhibition included some convincingly Surrealist English works of art. Henry Moore exhibited sculptures which dismembered and reassembled the human figure, as if from found objects. His forms looked vulnerable to incipient metamorphosis, and full of a possibility which might, for a few years in the later 1930s and early 1940s, be termed Surrealist. Eileen Agar exhibited her *Angel of Anarchy* and, having been selected for the

exhibition, began to experiment with automatic techniques and found materials. Her *Marine Object* is an example of the working of 'hasard objectif' or objective chance: elements found in the natural world are used to solve formal and emotional sculptural problems and to make an enigmatic and intriguing object.

Paul Nash was one of the most successfully Surrealist of the English artists. He showed several works including the paintings *Harbour and Room* and *Voyages of the Moon*, and the collages *Landscape at Large* and *Swanage*. His paintings owe much to the disconnected narratives and spaces created by de Chirico — *Harbour and Room*, for example combining inside with outside, the familiar with the impossible. Nash places the viewer inside a house, the safety and predictability of which is threatened by uncontrollable external forces. Nash impressed Benjamin Péret, who wrote in an introduction to the catalogue for an exhibition in Cambridge in 1937, 'This standard which the creatures of Eileen Agar brandish in their desperate course also floats at the entrance of *Harbour and Room* by Paul Nash where, according to Roland Penrose, ends *The Last Voyage of Captain Cook*'. Penrose's object of this title was also shown at the *International Surrealist Exhibition*. It is made from a plaster model bought in Paris, painted with strata to resemble the earth, encased in a metal globe made by a bicycle repairer in London and mounted on a base cut in diagonal section to suggest movement. Next to the model rests a saw handle. The whole is an object which hints at a frustrated and ambiguous violence: the female model has no arms, legs or head, but she

is decorated rather than disfigured by the strata which have clearly been applied to, rather than gouged out of her body. The saw has no blade and is outside the protective (or restrictive) sphere of the metal cage.

The English Surrealists enjoyed the full support of the French Surrealist apparatus. A lecture series was organised alongside the exhibition. Breton, Eluard and Dalí all spoke. Dalí's lecture was on 'Fantômes paranoïaques authentiques' (Authentic Paranoiac Phantoms) but he delivered it, inaudibly, from inside an old-fashioned diving suit. He provided the London public with a memorably Surrealist event, nearly suffocating inside the glass helmet of the suit and having to be rescued with a hastily procured spanner. A week after Dalí's lecture, the Surrealist Group in England was formed. In September, this group issued the fourth number of *The International Surrealist Bulletin*, and English Surrealism came of age. Those artists who had no real affinity with Surrealist ideals dropped out, and artists such as Maddox joined. The group operated along lines as uncompromising as Breton's Parisian movement: in 1947 they issued a *Déclaration du groupe surréaliste en Angleterre* (Declaration of the Surrealist Group in England) in the catalogue of the *International Surrealist Exhibition* at the Galerie Maeght in Paris. In it they announced the expulsion from the group of Henry Moore, 'for making sacerdotal ornaments', Herbert Read for eclecticism, Humphrey Jennings for accepting the OBE and David Gascoyne 'for mystification'.

The International Surrealist Bulletin was another example of the Surrealists' expansionist ambitions. Three earlier numbers had been issued a year before the English number, by Surrealist groups set up in Prague, the Canary Islands and Brussels. In 1937 the *International Surrealist Exhibition* took place in Tokyo and in 1938 the hugely successful third exhibition in the series, which was held in the Galleries des Beaux Arts in Paris, included the work of seventy-five artists from fifteen nations. A smaller version of the exhibition toured to Amsterdam. The same year, Breton made his first trip to Mexico, a country 'where the world's heart opens out', with which he was immediately impressed. He spent time with Diego Rivera and Frida Kahlo, finding the paintings of Kahlo in particular 'intuitively Surrealist':

My surprise and joy was unbounded when I discovered, on my arrival in Mexico, that her work has blossomed forth, in her latest paintings, into pure surreality, despite the fact that it had been conceived without any prior knowledge whatsoever of the ideas motivating the activities of my friends and myself ... I was witnessing here, at the other end of the earth, a spontaneous outpouring of our own questioning spirit: what irrational laws do we obey, what subjective signals allow us to establish the right direction at any moment, which symbols and myths predominate in a particular conjunction of objects or web of happenings, what meanings can be ascribed to the eye's capacity to pass from visual power to visionary power (Breton, *Le Surréalisme et la peinture*).

Kahlo never joined a Surrealist group, but Breton remained sympathetic to her work, writing an introduction to the catalogue for her exhibition at the

47
Frida Kahlo

What the Water Gave Me 1938

Oil on canvas
96.5 × 76.2 (38 × 30)
Collection of Tomas Fernandez Marquez, Mexico City

48
Salvador Dalí

The Persistence of Memory 1931

Oil on canvas
24.1 × 33 (9½ × 13)
The Museum of Modern Art, New York

Julien Levy Gallery in New York in the hope that it might travel to Paris. In 1940, Breton organised the fourth *International Surrealist Exhibition* in Mexico City.

That year also brought the occupation of France by the Germans. Many artists fled Europe. Surrealism, which had already spread to America, set up its new headquarters there. Breton, Masson (who by this time was back in the Bretonian fold), Ernst, Tanguy and Man Ray together with Roberto Matta Echaurren, a Chilean painter who had settled in Paris and shown in the 1938 *International Surrealist Exhibition*, established a new forum for Surrealist thought and practice. They published first in *View*, an avant-garde literary magazine sympathetic to Surrealist ideals, and, from June 1942, in their own *VVV*, a periodical dedicated to Surrealism in exile.

Surrealism had first come to New York in 1932, with the exhibition *Surrealism* at the Julien Levy Gallery. This exhibition both introduced the American public to Surrealist art and launched Surrealist artists onto the American art scene. Dalí in particular was a great success. His *The Persistence of Memory*, his famous 'soft watches', was shown in this exhibition for the first time, and in 1933 and 1934 he had solo shows with the same gallery. He became a star. To celebrate his arrival in New York in November 1934 he published *New York Salutes Me*, a tract in which he identifies himself as an ambassador for Surrealism:

> The Surrealists are involuntary mediums for an unknown world. As a Surrealist painter myself, I never have the slightest idea what my picture means. I merely transcribe my thoughts, and try to make concrete the most exasperating and fugitive visions, fantasies, whatever is mysterious, incomprehensible, personal and rare, that may pass through my head.

Increasingly, however, Dalí became an ambassador for himself. He lectured at the Museum of Modern Art, was on the cover of *Time* magazine, and persuaded the cream of New York society into Dalinian costume for an 'oneiric ball' given in his honour by Caresse Crosby. He was much in demand as a portraitist, painting rich and influential American patrons in Surrealist guise, performing feats of metamorphosis upon their distinctive profiles or chaining them to painted cliffs with their jewellery. Although throughout most of the 1930s Dalí remained close to Breton's vision of Surrealism, by 1940 Breton had become impatient with what he perceived to be Dalí's cheapening of Surrealism into portraiture, fashion and fascist politics. Dalí was fascinated by Hitler. His *Mountain Lake* of 1938 is part of a series of paintings inspired by Chamberlain's phone calls to Hitler which culminated in the Munich Agreement of 30 September 1938. Towards the end of the decade and into the 1940s, Dalí, 'Avida Dollars', became more and more alienated from the Surrealist group.

Breton was never really happy in America. He refused to learn English,

believing that thought and language are so interdependent that to speak another language imperfectly would endanger the pure creativity of his unconscious mind. This left him relatively isolated. He sought consolation in the members of the Parisian Surrealist group who had fled Europe with him, in a renewed friendship with Marcel Duchamp, and in the Art of this

49
Matta (Roberto Matta Echaurren)

Black Virtue 1943

Oil on canvas
76.5 × 182.6
(30¼ × 72)
Tate Gallery

50
Arshile Gorky

Waterfall 1943

Oil on canvas
153.7 × 113
(60½ × 44½)
Tate Gallery

Century gallery opened by Peggy Guggenheim to show Surrealist and other avant-garde art. In June 1942, *VVV* published Breton's 'Prolegomènes à un troisième manifeste du surréalisme ou non' (Prologomena to a Third Surrealist Manifesto or Not), and Breton gave a lecture to French students at Yale University, 'La Situation du surréalisme entre les deux guerres'

(The Situation of Surrealism between the Two Wars). In his lecture he denied the oft-reported death of his movement and re-established Surrealism as a force for the 1940s:

> I know: even during these last months at Yale you probably heard it said that Surrealism is dead. When I was still in France, I had promised myself to display in public one day everything I had been able to collect in the way of newspaper articles built on this theme: 'Surrealism is done for!'. It would have been rather piquant to show that they have followed on one another almost monthly since the date of its foundation!

Breton insisted that Surrealism could only in fact die if another movement was ready to take its place:

> With all due respect to some impatient gravediggers, I think I understand a little better than they do what the demise of Surrealism would mean. It would mean the birth of a new movement with an even greater power of liberation. Moreover, because of that very dynamic force which we continue to place above all, my best friends and I would make it a point of honour to rally around such a movement immediately.

The most influential of Breton's 'best friends' in America were Tanguy, Masson and the recently recruited Matta. The three were important to young American artists, for whom they represented a type of internationalism through which to escape the narrow emphasis on national art currently prevalent in the United States. American artists tended not to join the Surrealist movement; an exception is Arshile Gorky, for whom Breton wrote the preface to his 1945 exhibition at the Julien Levy gallery which was incorporated into later editions of *Le Surréalisme et la peinture*. But the influence of Surrealism was most keenly in evidence in the emerging generation of American Abstract Expressionist painters. Although Surrealism was not in itself a force for abstraction, several of the young American painters experimented with automatic techniques, and were impressed with the Surrealist elision of conscious and unconscious imagery. Jackson Pollock had his first solo exhibition at Peggy Guggenheim's Art of this Century gallery. He was close to Matta, and was inspired, by the spatial tensions evident in Matta's Surrealist work as well as by an interest in Miró, to develop the technique for which he is best known. Paintings such as *Number 23* were made by laying a canvas flat on the floor and dripping trails of paint onto it. As with Masson's automatic drawings and paintings of the 1920s, the technique links the imagery produced with the gesture used to produce it: Pollock's marks are calligraphic, they link his hand to his mind and retain lingering suggestions of fantastic, unconscious forms.

Breton returned to Paris in May 1946. In July 1947, with Marcel Duchamp, he organised an *International Surrealist Exhibition* at the Galerie Maeght. The exhibition re-established the focus of Surrealism after the war, welcomed new members and associates, and celebrated the by now truly international status of the movement. The same year, Breton founded Cause, a kind of 'action bureau' charged with the co-ordination of the various different national Surrealist groups. Breton himself remained at the centre of the movement,

and the artists he had championed – Miró, Masson, Ernst, Magritte, Dalí – stayed in touch to greater or lesser degrees as they began to be fêted as masters of modern art. Breton continued to exercise strict control. He guarded the integrity of Surrealism to the end and, with Benjamin Péret, the only original member of the group who was at no time expelled from it, was careful to allow new elements to enter the movement while resisting its acceptance into the norms and conventions of art history. With Breton's death in 1966 Surrealism finally lost its coherence as a movement. Its diffuse nature became apparent, and it dispersed into a network of influence and inspiration, constantly to be rediscovered in new places and by new generations.

51
Jackson Pollock
Number 23 1948
Enamel on gesso on paper
57.5 × 78.4 (22¾ × 31)
Tate Gallery

6

'A collision exacted on the eyes'
SURREALIST PERFORMANCE, THEATRE AND CINEMA

Surrealism was christened in the theatre, and in many ways theatre seems the ideal Surrealist art form. A medium of shared experience, it is a mechanism for the transmission of the inner life of the playwright to the minds of the audience. A writer who inhabits the marvellous needs only a few actors to transport the audience there with them. From the beginning, Surrealism as a movement had an innate sense of the theatrical. Like Dada before it, Surrealism staged its interaction with the public, turning exhibitions into dramatic narratives and theatrical events.

Arriving at the 1938 *International Surrealist Exhibition* in Paris, for example, the visitor was met by Dalí's *Rainy Taxi*. Two mannequins, one with the head of a shark, sat inside the taxi, which was continuously drenched with water. The mannequins sat among vegetation, on which fed enormous burgundy snails. From the taxi, the visitor passed down a passage of welcoming Surrealist mannequins into a great central hall, arranged by Marcel Duchamp into an integrated experience, a tableau-vivant of Surrealism. Duchamp transformed the hall into a grotto, with twelve hundred sacks of coal suspended from the roof. The floor of the room was covered in a carpet of leaves. Visitors' reactions to the exhibition were manipulated by Duchamp like a theatre director shaping the experience of an audience. Visitors were given torches with which to find their way around in the semi-darkness. In searching for the works on display, they were forced to participate in the exhibition, to become complicit in its Surrealist endeavour.

Despite this innate theatricality, however, Surrealism had only a minor

interest in the theatre as an art form in its own right. One of the most celebrated, seemingly 'Surrealist' plays of the 1920s, Jean Cocteau's *Orphée* (*Orpheus*), was in fact a satire on the movement. Failing properly to engage with the theatre, the Surrealists found themselves mocked by it. It was Cocteau's ballet *Parade* at which Apollinaire coined the name Surrealism, and initially Cocteau moved in at least proto-Surrealist circles. In 1919 he was friendly with Aragon and was part of the group of artists and writers who collected around Tristan Tzara when he first brought Dada to Paris. Cocteau argued violently with Breton and Soupault, however, and never became a member of the Surrealist group. By 1926, he was familiar enough, and disillusioned enough, with Surrealism to produce a savagely accurate parody: *Orphée* lays bare the aims and aspirations of Breton and his friends.

The play opens with Orphée, the hero, taking poetic dictation from a pantomime horse which stamps out letters with its foot. Orphée's 'poetic method' ridicules Bretonian automatism and the Surrealist attempt to record the secrets of an undirected unconscious. The horse is referred to as Orphée's 'dada', his hobbyhorse. It is a visual pun on Dada and therefore Surrealism, which was at that time still synonymous with the Dada movement in the minds of the public. There is perhaps also an inference that the Surrealists, in moving away from Dada failed, like Orphée with his horse and presumably unlike Cocteau himself, to understand what Dada was trying to say. The horse spells out *M.E.R.D.E. (SHIT)*, from which Orphée struggles to achieve inspirational coherence.

Orphée plays with the rhetoric of discovery which characterises the Surrealist idea of the marvellous. Enchanted with the horse's 'poetry', Orphée exclaims, 'I would give up my entire poetic works for one of those little phrases in which I hear myself like you hear the sea in a seashell'. The play's central image is one of a penetrable mirror: Orphée passes through to the other side of a mirror in search of his lost wife Eurydice. The Surrealists present at the play recognised themselves as parodied by Cocteau, and even applauded his wit. Close parody was a weapon they used themselves. In October 1926 the poet Max Jacob wrote to Cocteau, a close friend, that someone had assimilated his writing style in order to attack both himself and Cocteau in a magazine: 'the writers imitate perfectly my poetic voice and style. There is in it a literary finesse which smells of Surrealism'.

Aragon, Roger Vitrac and Antonin Artaud did write Surrealist plays. Artaud in particular, although he was part of the movement for only a short time between 1924 and 1926, attempted a theory of Surrealist theatre and tried to set up a theatre company dedicated to the production of Surrealist

work. The company was called the Alfred Jarry theatre in memory of the playwright whose *Ubu Roi* (*Ubu the King*), first performed in 1896, had a revolutionary impact on avant-garde theatre. Jarry was troubled by the necessity of living and functioning in a world he perceived to be both meaningless and absurd. To help him cope, he invented 'pataphysics', a quasi-

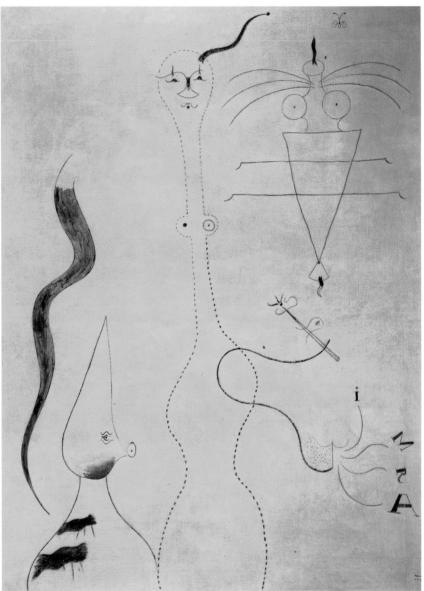

53
Joan Miró
Portrait of Mme B. 1924
Oil and charcoal
on canvas
129 × 95.3
(50¾ × 37½)
Berry-Hill Galleries,
New York

philosophy, and Père Ubu, an omnipotent alter-ego. Jarry asserted that there could be no distinction between the worlds of objective and subjective fact, between life and fantasy. He placed the stage at the intersection between the two, and played upon it with enormously influential invention. *Ubu Roi* begins with one triumphant, scatologically invented nonsense-word, 'Merdre!'

The Surrealists were in sympathy with Jarry's project. The comical, rotund figure of Ubu finds his way into several Surrealist paintings, and the members of the group saw an obvious parallel between Jarry's and their own exploration of the space on the boundary between the objective and the subjective. They did not, however, echo Jarry's conviction that the stage was the literalisation of that space. Breton is in fact known to have mistrusted the theatre as bourgeois and profit-orientated, and he did not give Artaud his unqualified support. The Alfred Jarry theatre ran for four seasons between 1927 and 1929 before collapsing into bankruptcy. Artaud insisted that it had been created 'to help itself to the theatre, and not to serve the theatre', that it looked to 'carry behind it all the fatality of life and the mysterious meetings of dreams', but he could not make its hallucinatory, confrontational plays a success.

Artaud, influential on subsequent theatre though he was, had an extremely stormy relationship with Surrealism. He was for a time the director of the Bureau for Surrealist Research, and edited an issue of *La Révolution surréaliste*, but he quarrelled violently with Breton who despised him for, among other things, making his living through commercial films. Artaud was a film and theatre actor as well as a writer. He appeared in several artistically and critically dubious films, as well as in two of the period's most successful: Abel Gance's *Napoléon* and Carl Theodore Dreyer's *La Passion de Jeanne d'Arc* (*The Passion of Joan of Arc*). There are no Surrealist elements in either of these films, but Artaud himself wrote the script for one of the three greatest examples of Surrealist cinema — *La Coquille et le clergyman* (*The Seashell and the Clergyman*). Artaud neither acted in nor directed it, and he afterwards claimed that it was ruined by its director Germaine Dulac. It was first shown at the Cinéma des Ursulines in Paris in February 1928. The Surrealists attended, although Artaud had written the script while isolated from the movement, and they supported Artaud in his protests against the mis-direction of the film. Artaud was interested in the visceral possibilities offered by cinema. Rather than simply writing a film based on the dream, a translation of the events of a particular dream, he attempted an exhaustive cinematic investigation into the nature of dreaming. He thought that cinema could reduplicate the mechanisms of the dream, and re-constitute the sense of volatility and lack of control experienced by a dreamer. *La Coquille et le clergyman* was rejected when it appeared before the British Board of Film Censors: 'this film is so cryptic as to be meaningless. If there is a meaning, it is doubtless objectionable'. Artaud himself sited the film's 'meaning' in its manipulation of the human body, both that of the actors and the audience, and in how the physicality of that manipulation could be transformed into emotion and understanding. He said he was searching 'for a film with purely visual sensations in which the force would come from a collision exacted on the eyes'.

The importance Artaud placed on the eye as the locus of the transmission of meaning from writer to audience is echoed in the most famous sequence of Surrealist cinema: the opening of *Un Chien Andalou* (*An Andalusian Dog*): by Dalí and Luis Buñuel:

PROLOGUE
ONCE UPON A TIME . . .
A balcony in the dark
Indoors, a man is whetting his razor. He looks up
through the window at the sky and sees . . .
A fleecy cloud drawing near to the full moon.
Then a young girl's head with staring eyes. A
razor-blade approaches one of the eyes.
Now the fleecy cloud passes over the moon.
And the razor-blade passes through the girl's eye
Slicing it in two.

The eye is a consistent Surrealist icon. It appears and reappears throughout Surrealist imagery, both visual and poetic, as a site of confrontation, conjunction and communication. The eye links inner and outer, subjective and objective. It is a 'glace sans tain', a mirror without silvering through which the Surrealist marvellous may be glimpsed and perhaps attained. It presides over the opening of *Un Chien Andalou*, a powerful metaphor for the originality, and surreality, of the film's vision.

Un Chien Andalou was first screened at Studio 28 in Paris in October 1928. Its script, written by Dalí and Buñuel together, was published in *La Révolution surréaliste*, prefaced by a profession of faith from the Spanish film maker, a newcomer to Surrealism: 'the publication of this script expresses my unreserved and complete adherence to Surrealist thought and activity. *Un Chien Andalou* would not have existed without Surrealism'. The film is almost a manifesto for Surrealist cinema. Its plot is disconnected and dream-like; its technique hallucinatory and dependent on displacement and montage. Although Artaud recognised some of his own ideas in it, Dalí and Buñuel claimed it was 'without precedent in the history of the cinema'. Unlike contemporary avant-garde films, *Un Chien Andalou* relied on the subversion of the real world rather than flight from it. Where other films were abstract, interested primarily in photographic effects and the manipulation of light and shadow, Buñuel and Dalí's film dissolved one easily recognisable image into another at high speed. At one point in the film, the camera focuses on the hand of one of the main characters. In the palm of his hand ants swarm out of a black hole. In quick succession, the image then dissolves into one of the armpit hair of a girl lying on a beach, the spines of a sea-urchin, and the head of another girl. In another sequence, the man caresses a girl's breasts, which turn into her thighs while he is touching them. In cinematographic montage, Dalí and Buñuel found a time-based equivalent both for the Dalinian paranoiac-critical method and for Bretonian automatism. As Buñuel wrote:

> The plot is the result of a conscious psychic automatism, and, to that extent, does not attempt to recount a dream, although it profits by a mechanism analogous to that of dreams. The sources from which the film draws inspiration are those of poetry, freed from the ballast of reason and tradition. Its aim is to provoke in the spectator instinctive reactions of attraction and repulsion.

Buñuel and Dalí both appear in the film. Buñuel is the man with the razor, and Dali is one of two clerics who pass across the screen. The script describes

54
Still from the film *Un Chien Andalou* of 1928.

55
Still from *Un Chien Andalou* (Salvador Dalí on the right).

56
Still from the film *L'Age d'Or* of 1930.

'first, a cork, then a melon, then two teachers from a church school, and finally two magnificent grand pianos. The pianos are filled with the carcasses of donkeys, their legs, tails, hind-quarters and excrement sticking out of the piano-cases'. Dalí's *L'Ane Pourri* (*The Stinking Ass*), his explanation of the paranoiac-critical method, was published in 1930: 'I believe the moment is at hand when, by a paranoiac and active advance of the mind, it will be possible (simultaneously with automatism and other passive states) to systematise confusion and thus to help to discredit completely the world of reality'.

1930 was also the year of Buñuel's second and final collaboration with Dalí, *L'Age d'Or* (*The Golden Age*). Dalí had less to do with this film, working with Buñuel on the script, but uninvolved in the actual filming. The film is more narrative than *Un Chien Andalou*, less dependent on individually poetic images. It is extremely anti-bourgeois and anti-Catholic, culminating in an orgy straight out of the Marquis de Sade's *120 Days of Sodom*.

The leader of the orgy is Jesus Christ. When the film was first screened at Studio 28 it caused a riot and had to be shut down. The cinema was stormed by members of the League of Patriots and the Anti-Jewish League. They threw violet ink at the screen, shouting 'we'll see if there are any Christians left in France!' They interrupted the screening at a point in the film where a monstrance (a church vessel holding the Host, the consecrated body of Christ) is thrown into a stream, and proceeded to let off smoke and stink bombs into the audience, attack the Surrealist

paintings and books on display in the foyer, cut the phone lines and cause 80,000 francs worth of damage to the cinema. Although right-wing newspapers later claimed that the damage had been caused by the film's 'bolshevist' audience, the spectators stayed until the end of the film, and signed a petition against the demonstrators on their way out.

L'Age d'Or and *Un Chien Andalou* are the high points of Surrealist cinema. Enormously influential, they redirected the course of avant-garde cinema while at the same time providing new energy and new audiences for Surrealism. Inevitably, their techniques found their way to America and into more mainstream cinema. In 1945, Alfred Hitchcock invited Dalí to collaborate on a dream sequence for his film *Spellbound*:

> When we arrived at the dream sequences, I wanted absolutely to break with the tradition of cinema dreams which are usually misty and confused, with a shaking screen etc . . . I wanted Dalí because of the sharpness of his architecture – Chirico is very similar – the long shadows, the infinite distances, the lines that converge in perspective . . . the formless faces.

Dalí's dream sequence was announced in the film by the dissolving of a real eye into an eye painted on a curtain. Hollywood had passed through to the other side of the Surrealist mirror.

57
Salvador Dalí on the set of Alfred Hitchcock's *Spellbound*.

A Legacy of Surrealism

Surrealism was a movement you could join, and one from which you could also be expelled. Centred in Paris, it was dominated and controlled by André Breton. It functioned most coherently between the two World Wars and effectively died with Breton in 1966. But Surrealism emphasised the importance of living the Surrealist life, and was as much a state of mind as a historical episode. Surrealist activity continues today – in the French group *Actual*, and around *Arsenal*, the Chicago-based English language journal of international Surrealism. Surrealist texts are translated and anthologised, and the impact of the Surrealist revolution still reverberates.

Surrealism has been enormously influential on successive generations of artists. Its emphasis on collectivity, on the breaking down of the distinction between private and public, artist and viewer has filtered into other ways of making art to surface in, for example, Situationism and Fluxus. Its interest in collage has perpetuated the collage medium as a viable way of making art, and its development of language, its insistence on spoken, written and visual imagery as elements of a common, primary mental material has long affected text-based work. Surrealist aspirations to automatism, the link they posited between thought and gesture, were formative in the work of the young Abstract Expressionists, artists who themselves were profoundly influential on subsequent art.

Surrealism is, however, difficult to pin down as one of that series of 'isms' into which modern art has traditionally been categorised. The facts of the movement's development cannot contain the pervasiveness of its influence,

and the emphasis placed by Breton on spirit rather than style makes its influence difficult to track. In one sense, any art which takes as its subject the workings of the mind, or which prioritises subjectivity, may be said to have Surrealist 'influence'. In addition, the word has passed into the language, so that any work of art, literature or film which is disjointed, hallucinatory or disconnected is likely to be classed as 'surreal'. Surrealism was an international movement, spreading its influence through the migrations of its members and the publication of their ideas. Its network of influence is potentially enormous.

One measure of Surrealism's success and popularity is the extent to which it has been taken up by the worlds of fashion and of advertising. The precedent for this was set by the Surrealists themselves: Dalí created window displays for Bonwit-Teller's store on Fifth Avenue in New York and collaborated with Elsa Schiaparelli on dress fabrics and on a 'Shoe-Hat'. Dalí did advertising work, and Magritte's *oeuvre* has been plundered by the advertisers. The raining bowler-hatted men of his *Golconda*, for example, have been replaced by cigarettes.

The dilution of Surrealism into the diversity of contemporary life would perhaps not entirely have displeased Breton. Surrealism was a movement which concerned itself with dissemination. Members of the group were fascinated with the possibilities for communication offered by the modern city, and with the potential for the marvellous embedded within those possibilities. Hence Aragon's *Le Paysan de Paris* (*Paris Peasant*), an inaugural Surrealist text which presents café, bar and city life as a series of Surrealist acts and objects:

58
Elsa Schiaparelli
Dress and Headscarf
c.1937
Silk crepe
Philadelphia Museum of Art. Given by Mme Elsa Schiaparelli

59
René Magritte
Golconda 1953
Oil on canvas
81 × 100.3 (31½ × 39½)
Menil Collection, Houston

60 *right*
CDP advertising campaign for Benson and Hedges, 1983.

Here, Surrealism resumes all its rights. They give you a glass inkwell with a champagne cork for a stopper, and you are away! Images flutter down like confetti. Images, images everywhere. On the ceiling. In the armchairs' wickerwork. In the glasses' drinking straws. In the telephone switchboard. In the sparkling air. In the iron lanterns which light the room. Snow down, images, it is Christmas. Snow down upon the barrels and upon credulous hearts. Snow on to people's hair and on to their hands.

MIDDLE TAR As defined by H.M. Government
H.M. Government Health Departments' WARNING: CIGARETTES CAN SERIOUSLY DAMAGE YOUR HEALTH

SELECT BIBLIOGRAPHY

Ades, Dawn, *Dalí*, London 1982.

Alexandrian, Sarane, *Surrealist Art*, transl. Gordon Clough, London 1970, 1989.

Aragon, Louis, *Paris Peasant*, Paris 1926, transl. Simon Watson Taylor, London 1971, 1987.

Breton, André, *Interviews*, Paris 1952, transl.

Breton, André, *Surrealism and Painting*, Paris 1928, 1965, transl. Simon Watson Taylor, London 1972.

Breton, André, *Nadja*, Paris 1928, transl. Richard Howard, New York 1960.

Breton, André and Soupault, Philippe, *The Magnetic Fields*, Paris 1920, transl. David Gascoyne, London 1985, 1994.

Breton, André, *Manifestos of Surrealism*, transl. Richards Seaver and Helen R. Lane, Michigan 1969, 1972.

Camfield, William A., *Max Ernst: Dada and the Dawn of Surrealism*, Munich and Houston 1993.

Caws, Mary Ann (ed.), *Surrealism and Women*, Michigan 1991.

Caws, Mary Ann, Kuenzli, Rudolf E. and Raaberg, Gwen (eds.), *Surrealism and Women*, Cambridge (Mass.) and London 1991.

Chadwick, Whitney, *Women Artists and the Surrealist Movement*, London 1985.

Dalí, Salvador, *Diary of a Genius*, London 1966.

Dalí, Salvador, *The Secret Life of Salvador Dalí*, London 1942.

Ernst, Max, *Beyond Painting, and Other Writings by the Artist and his Friends*, New York 1948.

Fer, Bryony, Batchelor, David and Wood, Paul, *Realism, Rationalism, Surrealism: Art Between the Wars*, New Haven 1993.

Freud, Sigmund, *Art and Literature: Jensen's Gradiva, Leonardo da Vinci and Other Work*, transl. James Strachey, Penguin Freud Library vol.14, London 1985, 1990.

Freud, Sigmund, *The Interpretation of Dreams*, transl. James Strachey, Penguin Freud Library vol.4, London 1976, 1991.

Gablik, Suzi, *Magritte*, London 1970.

Gascoyne, David, *A Short History of Surrealism*, London 1935, 1936, 1970.

Gooding, Mel, (ed.), *Surrealist Games*, London 1991.

Green, Christopher, *Cubism and its Enemies: Modern Movements and Reaction in French Art, 1916–1928*, New Haven and London 1987.

Hale, Terry (ed.), *The Automatic Muse: Surrealist Novels by Robert Desnos, Michel Leiris, Georges Limbour and Benjamin Péret*, transl. Terry Hale and Iain White, London 1994.

Legge, Elizabeth, *Max Ernst: the Psychoanalytic Sources*, Michigan and London 1989.

Levy, Silvano (ed.), *Conroy Maddox: Surreal Enigmas*, Keele 1995.

Magritte, René, *Collected Writings*, London 1987.

Martin, Richard, *Fashion and Surrealism*, London 1988.

Nadeau, Maurice, *The History of Surrealism*, Paris 1944, transl. Richard Howard, London 1968, 1987.

Penrose, Roland, *Miró*, London 1970.

Read, Herbert (ed.), *Surrealism*, London 1936.

Richardson, Michael (ed.), *The Dedalus Book of Surrealism vol.I: The Identity of Things*, Cambridge, 1993.

Richardson, Michael (ed.), *The Dedalus Book of Surrealism vol.II: The Myth of the World*, Cambridge 1994.

Rosemont, Franklin, *André Breton and the First Principles of Surrealism*, London 1978.

Rosemont, Franklin (ed.), *André Breton: What is Surrealism? Selected Writings*, London 1978.

Rubin, William, *Dada and Surrealist Art*, London 1969.

Short, Robert, *Dada and Surrealism*, London 1980.

Spies, Werner, *Max Ernst: Loplop, the Artist's Other Self*, London 1983.

Spies, Werner, *Max Ernst Collages: The Invention of the Surrealist Universe*, London 1991.

Sylvester, David, *Looking at Giacometti*, London 1995.

Waldberg, Patrick, *Surrealism*, London 1969.

Wilson, Simon, *Surrealist Painting*, Oxford 1876, 1982.

Webb, Peter and Short, Robert, *Hans Bellmer*, London 1985.

EXHIBITION CATALOGUES

Dada and Surrealism Reviewed, Arts Council, London 1978.

Salvador Dalí, Tate Gallery, London 1980.

Salvador Dalí: Rétrospective 1920–1980, Musée national d'art moderne, Paris, Centre George Pompidou 1979.

Salvador Dalí: The Early Years, Arts Council, London 1994.

Max Ernst: A Retrospective, London, Tate Gallery 1991.

Fantastic Art, Dada and Surrealism, Museum of Modern Art, New York 1936.

Magritte, South Bank Centre, London 1992.

Joan Miró, Museum of Modern Art, New York 1993.

Surrealism in England, 1936 and after: an exhibition to celebrate the 50th anniversary of the First International Surrealist Exhibition in London in June 1936, Herbert Read Gallery, Canterbury.

PHOTOGRAPHIC CREDITS

All photographs are by the Tate Gallery Photographic Department except those listed below.

The publishers have made every effort to trace all the relevant copyright holders and apologise for any omissions that may have been made.

© Artephot/Martin 37; Photo: Berry-Hill Galleries, New York 53; Photo: Brewster Arts Ltd 40, 41; British Film Institute Stills, Posters and Designs 54–7; Photograph by Michael Cavanagh and Kevin Montague 6; © CDP, London 60; Photo: Hickey-Robertson, Houston 59; © 1996 Museum Associates, Los Angeles County Museum of Art. All Rights Reserved 28; Photo: © 1996 The Museum of Modern Art, New York 11, 13, 15, 31, 48; Philadelphia Museum of Art 58; © Rheinisches Bildarchiv, Cologne 1, 16; Sprengel Museum Hannover 10; Photo: Telimage, Paris 52; Photo: M. Sarri, courtesy of the Vatican Museums 36.

COPYRIGHT CREDITS

Works illustrated are copyright as follows:

Bellmer, Duchamp, Ernst, Giamcometti, Gorky, Hausmann, Magritte, Masson, Matta, Miró, Picabia: © ADAGP, Paris and DACS, London 1997

Carrington, Pollock: © ARS, NY and DACS, London 1997

Arp, de Chirico, Oppenheim: © DACS 1997

Dalí: © DEMART PRO ARTE BV/DACS 1997

Other works: © The artist or the estate of the artist

Index